Finding your VISUAL VOICE

A Painter's Guide to Developing an Artistic Style

BY Dakota Mitchell
WITH Lee Haroun

NORTH LIGHT BOOKS
CINCINNATI, OHIO
www.artistsnetwork.com

fw
F+W PUBLICATIONS, INC.

Other fine North Light Books are available from your local bookstore, art supply store or direct from the publisher.

11 10 09 08 07 5 4 3 2 1

DISTRIBUTED IN CANADA BY FRASER DIRECT
100 Armstrong Avenue
Georgetown, ON, Canada L7G 5S4
Tel: (905) 877-4411

DISTRIBUTED IN THE U.K. AND EUROPE BY DAVID & CHARLES
Brunel House, Newton Abbot, Devon, TQ12 4PU, England
Tel: (+44) 1626 323200, Fax: (+44) 1626 323319
Email: mail@davidandcharles.co.uk

DISTRIBUTED IN AUSTRALIA BY CAPRICORN LINK
P.O. Box 704, S. Windsor NSW, 2756 Australia
Tel: (02) 4577-3555

Library of Congress Cataloging in Publication Data
Mitchell, Dakota
 Finding your visual voice : a painter's guide to developing an artistic style / Dakota Mitchell and Lee Haroun. -- 1st ed.
 p. cm.
 Includes index.
 ISBN-13: 978-1-58180-807-0 (hardcover : alk. paper)
 ISBN-10: 1-58180-807-0 (hardcover : alk. paper)
 1. Painting--Technique. 2. Painting--Psychological aspects. I. Haroun, Lee II. Title.
ND1500.M58 2007
751.4--dc22 2006027953

Edited by Stefanie Laufersweiler
Production edited by Jason Feldmann
Designed by Wendy Dunning
Production art by Kathy Bergstrom
Production coordinated by Matt Wagner

The permissions on pages 170-172 constitute an extension of this copyright page.
A metric conversion chart is located on page 175.

Dedication

Lee and I dedicate this book gratefully to the contributing artists who so openly and generously shared their art, their time and their personal experiences. And joyfully we dedicate it to all artists who are striving to connect with and express their unique visual voices in their work.

Acknowledgments

Lee and I would like to acknowledge Jamie Markle, North Light acquisitions editor, for recognizing the possibilities of this book when it was only a rough outline on a sheet of paper. We are also grateful to Stefanie Laufersweiler, the development editor who guided us in developing that outline into a completed book.

Special thanks to Helaine M. McLain, associate professor of art at Northern Arizona University, for her time and expertise in reviewing our manuscript and making many valuable suggestions. And to Laura Alexander for reviewing and commenting on the manuscript and for allowing us to incorporate her professional-quality photographs.

We were overwhelmed by the generosity of the contributing artists who were willing to send images, participate in interviews and answer our seemingly endless questions. Their beautiful images made this book possible.

ABOUT THE AUTHORS

My first memory of my passion for art is as a little girl sitting at the kitchen table drawing and redrawing a horse. I was fascinated with the idea of using a simple pencil and paper to create my experience of an animal in a way that had not existed before. Over the years, other endeavors seemed more important (I was so wrong!), and art remained on the back burner. Then, through a series of events which I describe in the Introduction, art once again became central to my life. I returned to college and earned my B.F.A. with an emphasis in painting.

I wanted to share my experiences in artistic self-discovery with others to provide them with the encouragement I wish I'd been given. If when you read this book, you move a step closer to expressing your own visual voice, it will have been worth the time and effort it took to communicate my philosophy and beliefs. Fortunately, I was wise enough to enlist the assistance of Lee Haroun, who was able to read my notes, ask questions and somehow come up with exactly what I wanted to say. Together, we send our heartfelt wish that our work helps you discover your visual voice and, in the process, other aspects of your life.

Let Us Know What You Think!

We welcome your thoughts and feedback about the book. Please send your comments to:

Lee Haroun
18160 Cottonwood Rd. #738
Sunriver, OR 97707

I was thrilled when Dakota asked me to work with her in bringing this book, her longtime dream, to fruition. As a professional writer, I love researching and exploring new topics. My lifelong interest in art dates back to when my parents framed and displayed—in the living room!—a painting I did in the first grade. Over the years, I studied the lives and work of many of the Masters. A highlight for me was taking an art history class at the venerable Prado Museum in Madrid.

I am fascinated by how learning can enhance our life quality and earned a doctorate in education after entering what is traditionally considered to be "middle age." My life motto: You can never learn too much or have too much fun!

CONTENTS

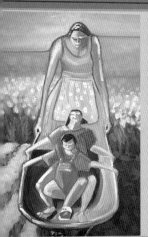
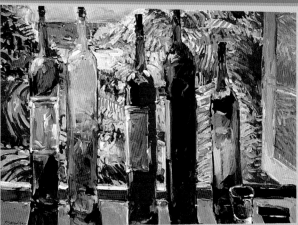

4 *Discover Your Composition Style* 96

Composition is what pulls everything together into a unified whole. It is an essential part of expressing your visual voice.

5 *Discover Your Painting Process* 130

The painting process is all that you do to produce a piece. There are countless ways to work and techniques available to communicate your artistic message.

INTRODUCTION

Artists paint to discover the truth. When we paint from our true selves, we express our hopes, ideas, beliefs and passions. Painting what is within us is a very powerful and personal process. We learn who we are by painting. The added benefit is that when viewers experience the painting, it also helps them to learn and grow. Because the artist created something that did not exist before, the viewer can see and experience the world differently.

This book is for artists who want to embark on the exciting journey of more clearly hearing their visual voice and developing their own language as painters. I have written it to provide you with:

- Guidance and tools for identifying and clarifying your visual voice

- Inspiration to follow your dreams of artistic achievement

- Help in focusing your learning efforts and avoiding unnecessary digressions in your artistic journey

What Is Your Visual Voice?

Your visual voice is the combination of instincts and feelings that encourages you to pick up a paintbrush and create work that is your own. Your visual voice is intuitive, not intellectual or consciously guided by reason. Cristina Acosta, an artist contributor to this book, describes visual voice as "the piece of magic inside ourselves— the amazing actuality within us."

Finding and expressing your visual voice is about following your passion. I once read that ignoring your passion is like dying a slow death. The author went on to suggest that passion whispers to us through our feelings, beckoning us to work to achieve our highest good. Following your passion sets into motion a creative cycle in which passion fuels your painting and your painting then refuels your passion.

Listening to Your Voice

When you listen to your visual voice and follow your intuitive artistic truth, you feel energized, stimulated and connected. You are, to use popular expressions, "in the zone" or "in the groove." Your creative juices are flowing and you receive the energy needed to create what you feel. At the same time, you experience a sense of peace and calm, the satisfaction of doing what you are meant to do.

If being in the zone leads to good feelings and good art, why don't we enter that zone more often? Why do we often ignore our inner voice and fail to create art that is truly our own? One problem is that our voice can easily be drowned out by the musts, shoulds and have-to's in our complex, technological, reason-oriented world. And if you have studied art, either formally or informally, you know the tendency of many instructors and authors is to present themselves as knowing "the way." The fear of being wrong is a common block for artistic expression. Shaun McNiff, in his book *Trust the Process*, suggests that "it is not lack of

talent that keeps us from creative expression, but fear and avoidance of the uncertainty that comes with creating." Heeding the messages sent by our visual voice is one way to free us from the fear, although all artists evolve through trial and error before reaching the point of trusting their visual voice.

Your Visual Voice and Authenticity

Have you ever wondered why some artists appeal to a wide audience while others, who do similar work, are not nearly as successful? Or have you tried painting in the style of someone whose work you admire, only to find the process and results less than satisfying? In both cases, the spirit behind the originating artist is missing; the visual voice that first articulated the ideas no longer supports the work. When artists dispassionately borrow ideas and techniques, their work will lack the spark of the original piece. It's a difficult concept to describe, but when artists are 100 percent into the process, their work has a genuine quality that rings true. Brian Davis, whose beautiful flower paintings appear in this book, tells his students, "If you're not passionate about your work, it will come across. You put yourself in a big hole if you do things you don't love."

Achieving Your Artistic Dreams

Succeeding as a painter requires believing in yourself and in your abilities. It takes faith to strike out on your own, boldness to try original ideas. It also takes work to learn the principles and techniques necessary to fully express your visual voice. Artistic geniuses are very rare, and even they must learn basic principles and methods to work with their chosen media. How many times have you heard someone say, "I wish I could do art. I can't even draw a straight line," verbalizing the erroneous belief that all artists are born with natural ability and special knowledge? Can you imagine anyone making these assumptions about a physician or an engineer?

So banish any beliefs you may have that you lack talent and creativity. Artistic accomplishment, like any worthwhile achievement, takes study, effort and practice. To fully realize your potential as an artist, you must put in the work—what I call the "brushtime." But the work can pay off. I really can't think of anything more powerful than when passion and skill are combined!

My Story: On a Personal Note

From my earliest childhood, I received internal intuitive messages that urged me to pursue art, but I was unable to understand them until much later in life. I was raised in rural North Dakota and the only "art" I was exposed to was calendars with photos of farm equipment! Even at the university, I pursued nursing because I was good at science and math and this was a "logical" choice for a female in those days.

Over the years, I always knew something was missing from my life. I earned various degrees,

pursued different careers, and lived in many different locations, always searching ... but for what? Two experiences finally led me to discover art. The first was seeing a beautiful painting in a co-worker's office and learning that she had painted it herself. I was absolutely astonished. When I expressed my own lack of talent, she gave me a simple response: "It does not take talent; it takes learning the techniques and lots of practice." In

spite of my doubts that this could be true, I signed up for my first art class.

The final turning point for me took place in Paris at the Louvre. I visited the museum only because I thought I should, and would be embarrassed to say I hadn't. But when I saw the rooms filled with original art, the floodgates of emotion opened for me. I was affected to the very core of my soul and found myself in tears as I experienced my long-hidden passion. The quiet, intuitive voice now became a shout, and when I returned home, I began the study and practice of painting that has become the most exciting and rewarding part of my life. My message to you is to listen to and respect your inner visual voice and allow your life to open to new possibilities.

Principles to Create By

Artist Elmer Bischoff offered four principles that I feel embody what it takes to get in touch with our visual voice. I keep a copy of these in my studio where I can see them as I work.

1. Work hard.

2. Take chances.

3. Respect the validity of your own imagery.

4. Accept the struggle of the creative process.

GETTING THE MOST FROM THIS BOOK

I recommend that you read through the book sequentially because there is a logical flow to it, with the chapters building and expanding on each other. Engage your feelings as you read; consider how the images and concepts affect you emotionally and physically. In addition, I encourage you to do the suggested exercises as you work through the book.

Each chapter includes a number of special features to assist you in your process of self-discovery:

- **Paintings** from thirty contributing artists. Their purpose is to illustrate the many different approaches, elements and concepts in painting. I believe the work of other artists can serve as a springboard for ideas to encourage your personal creativity and as examples of how to solve artistic problems.

- **Quotes** from a variety of artists who offer passionate and often contradictory opinions. I have included these to present different viewpoints and to demonstrate that there really is no "one right answer" in art. Opinions are to be considered and learned from, not internalized and seen as "the way."

- **Step-by-step demonstrations**, presented in the words of the artists, to show how different artists approach their work and the process that leads to a completed painting.

- **Meet the Artist** interviews in which working artists share their experiences in discovering their visual voice, their painting techniques and their advice for other artists.

- **Review and Reflect**, chapter-ending sections that contain images and reflection questions to give you opportunities to apply the concepts of the chapter and gain insight into your visual voice.

- **Now It's Your Turn** exercises that encourage hands-on practice so you can explore each chapter's concepts and feel how they work for you.

The book's concluding section contains two features to summarize and help you use all that you've learned about yourself as an artist:

- **Self-Assessment Summary**, with sections to fill out as you complete each chapter. Use this tool to record your own ideas and preferences.

- **Where to Go From Here**, containing suggestions for a personal action plan to guide your artistic learning and progress.

1 DISCOVER YOUR SOURCES OF INSPIRATION

A first step in discovering your visual voice is identifying your sources of inspiration. Where do your ideas about what and how to paint come from? Sources of inspiration are determined by your personality, thoughts, ideas, experiences and preferences. They come from your core—who you are—and speak to you through your visual voice. They are heart choices, not head choices. If you choose to go against your intuitive, visual voice, you will miss the satisfaction and deep joy that painting can bring.

It is not uncommon for artists to try to emulate what they admire, perhaps something wonderful they see in a museum or a gallery. But if the inspiration doesn't come naturally, it won't work. At best, these artists never fulfill their true potential. At worst, they lose interest and give up painting. This happened to an acquaintance of mine. She believed that she should paint more loosely, in the style of a classmate whose work she admired. But loose was not her nature, and because she tried to follow someone else's path, she eventually became so frustrated that she quit painting altogether.

"Doing your own thing" is essential in painting. As Albert Pinkham Ryder put it, "Imitation is not inspiration, and inspiration only can give birth to a work of art. The least of man's original emanations is better than the best of a borrowed thought." So never be afraid to listen to your own artistic voice, the one springing from the feelings and urges that inspires you to pick up a brush!

> "If you hear a voice within you saying, 'You are not a painter,' then by all means paint, and that voice will be silenced."
>
> —VINCENT VAN GOGH

Are you inspired by feelings or imagined thoughts?

Do you want to re-create what you see?

Are you inspired by your surroundings?

Do you want to express the intangible?

EXTERNAL FOCUS

Most beginning artists start by drawing their inspiration from what they see around them. In fact, most art teachers and working artists believe that students should first learn to draw what they see. Many artists love the challenge of depicting the physical world and thrive with this approach. The artistic representation of the external world becomes their lifelong endeavor because it fulfills their passion. This may be true for you, too. Inspiration based on what you see is *externally focused*. Another word to describe this approach is *objective*, meaning that it is based on what you perceive rather than on something that exists only in your mind. A wide variety of subjects may be inspired by and explored through external focus—anything, in fact, you can see with your eyes.

Throughout human history artists have been inspired to paint what they see. The challenge of

"Only that art is viable which finds its elements in the surrounding environment ... we must draw inspiration from the tangible miracles of contemporary life."

—UMBERTO BOCCIONI

Recording the Details
Society tends to regard with awe the ability to record the world in vivid detail, and many artists find pleasure in trying to achieve this. Brian Davis draws his inspiration from flowers he finds near his home. His artistic goal is to encourage viewers to recognize and feel the light as it creates shapes and various effects on the petals of each blossom. In fact, the light is the real subject. In his words, "The flower is the stage, the light is the dancer."

SUNLIGHT DANCE | Brian Davis | Oil | 30" × 24" (76cm × 61cm)

capturing a recognizable three-dimensional image on a flat surface has fascinated humans for centuries. This inspiration is evident in the ancient, beautiful cave paintings scattered throughout southwestern France and northern Spain. Skilled artists, using simple materials, represented what they saw in their environment. The focus of art throughout much of history has been to create as realistic an image as possible.

In the Western world, most painters—especially those who depended on wealthy patrons for their livelihoods—adhered to the artistic conventions of their times, daring to deviate only after they had secured a good reputation. European art academies maintained strict control over artists, establishing criteria for "good art," and refusing to show work they considered unacceptable. In the late 1880s, however, the power of the academies began to be undermined by a group of French painters who were inspired by the science of optics to depict reality in new and surprising ways. These *Impressionists* paved a path toward acceptance for other artists who wanted to paint what they saw in creative, original ways.

"... I know I could spend the rest of my life in copying a chair."

—ALBERTO GIACOMETTI

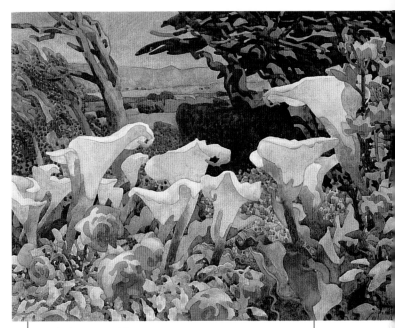

Painting From Nature
This artist paints on location. Painting outdoors is called *plein air* painting and is growing in popularity. Notice that even though she paints from nature, Carolyn Lord's work is highly personalized. In this piece, she chose an interesting angle from which to paint the flowers and does not depict them in great detail.

LEEWARD GARDEN | Carolyn Lord | Watercolor
22" × 30" (56cm × 76cm)

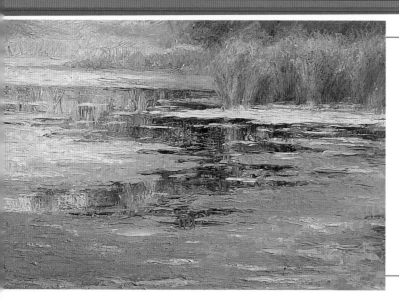

Capturing Summer Light

Like Claude Monet, in his paintings of Rouen Cathedral and haystacks, Susan Sarback is interested in painting the same subject under varied conditions. Sarback has developed her powers of observation and her technical abilities to visually record the differences that occur at various times of the day, under diverse weather conditions and at different seasons of the year. *Morning Pond* was painted in June from about 9 A.M. to 10:30 A.M., capturing the bright, warm light of a summer morning.

MORNING POND | Susan Sarback | Oil
16" × 20" (41cm × 51cm)

"I am inspired by the simple, everyday interactions of the animals in their environment: the way that light dances across the form, the harmony of color relationships, and the shapes of light and shadow."

—CHERI CHRISTENSEN

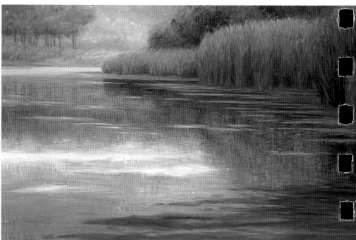

Capturing Autumn Light

Autumn Pond was painted in October between 8 A.M. and 9:30 A.M., in the first full light of a crisp autumn day.

AUTUMN POND | Susan Sarback | Oil | 16" × 20" (41cm × 51cm)

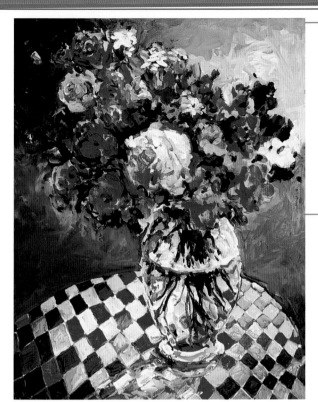

Expressing Yourself Through What You See

This particular artist is a high-energy person with a multitude of interests. His zest for life is reflected in this richly colored floral arrangement. Although he is painting a vase of flowers, he freely distorts the scene by tipping the tabletop forward to move the flowers closer to the viewer and intensify their opulence. This is a good example of how, through your painting, you can personalize what you see.

CAFÉ BOUQUET | Robert Burridge | Acrylic
48" × 36" (122cm × 91cm)

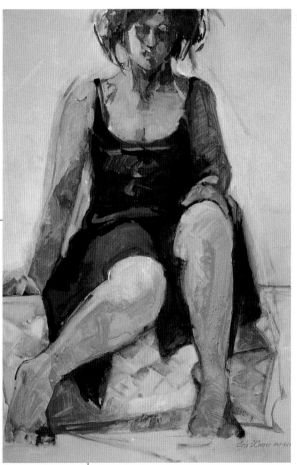

Painting From Models

Some externally focused artists paint from models. Figure drawing demands a higher degree of accuracy in observation than either landscape or still life. This is because we all know what a human figure looks like and can see immediately if it is not drawn well. This does not mean the figure must be realistically rendered in photographic detail. In this image, Carla O'Connor has painted in a very free, loose manner, but has wonderfully captured the womanliness of her model.

THE QUILT | Carla O'Connor | Gouache
30" × 22" (76cm × 56cm)

Susan Sarback

"I express who I am through what I see."

SUSAN SARBACK is the founder and principal instructor of The School of Light and Color located in Fair Oaks, California. She is an externally focused artist who draws her inspiration directly from what she sees. As she puts it, "I get my inspiration from observing the world around me. Something that I see triggers an internal response that inspires me to create a piece of art."

What is your source of inspiration, and how do you approach your painting?
My source of inspiration comes from observing the world outside myself. My focus of interest is the quality of light. When painting outdoors, I am interested in how colors relate under a given light source, whether it be sunny, cloudy, stormy or foggy. From years of practice, I have developed a refined visual perception which enables me to see and sense the interaction of light and color. At the same time, my experiences, feelings and thoughts—my state of consciousness—influence how and what I paint. I express who I am through what I see.

Do you push your colors beyond what you actually see?
Well, I'm not making up the colors. To the average eye, the color in my paintings may seem like an exaggeration, but it really is the color that's there. I learned to observe and see color through years of study with Henry Hensche, a master painter who gave art workshops in the eastern U.S. Your abilities to observe, when trained, transform the color. For me, art isn't just about painting, it's about transforming your consciousness.

What is your process as you work on a painting?
I make constant comparisons and ask myself questions like: "Is the color lighter or darker? Cooler or warmer? Brighter or duller?" I concentrate on maintaining keen perception, although now it's all pretty intuitive because I've trained my hands and eyes to work together.

PHOTO BY ROY WILCOX

Painting What Attracts Your Eye
In this painting, Sarback was particularly interested in showing the juxtaposition of the dramatic dark branch next to the subtle hues of this twenty-mile distance. The challenge was to create a unified painting with a sense of strength and expanse while using no blacks or browns.

REACHING BEYOND | Susan Sarback
Oil | 20" × 30" (51cm × 76cm)

How have your paintings changed over time?

My recent paintings are becoming less realistic and more about abstract principles. I'm using rhythm, pattern and movement as much as color. This shows in my Pond Series (examples on page 14). Color, shape and design are now more important than subject matter. I don't abstract to the point of making my subject unrecognizable, but I'm moving away from descriptive realism.

What advice would you give readers who want to use color based on light?

It's important to understand the nature of full-spectrum color. Learn to see color objectively, and then paint color relationships the way they appear—not what you want them to be. Light and color are more beautiful than what we even imagine. To truly be receptive to this great beauty, it's best not to paint using only colors that appeal to you. You have to move beyond painting what you think is good, correct or pretty. You will develop your own unique expression, but first learn the language and fundamentals of art.

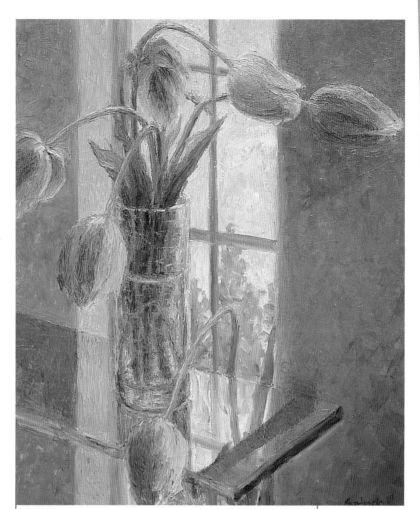

Painting What Fascinates You

The artist was fascinated by the color and shape of these graceful falling tulips contrasted against the sharp angles of the glass shelf, the windowpanes and the wall. The freshness of these colors creates the feeling of spring light, which also is caught in the view through the window.

TULIPS ON GLASS | Susan Sarback | Oil
20" × 16" (51cm × 41cm)

INTERNAL FOCUS

Until very recently in human history, artists were expected to paint what they saw, rather than what they felt or imagined. Drawing inspiration from one's own heart and mind is *internal-focus* inspiration.

An important contribution of the Impressionists was that a painting does not have to portray its subject photographically. Although their work was initially ridiculed, they started a ripple effect that transformed the art world. In their wake came a succession of other experimental and creative approaches to painting. Here are a few examples you might find interesting to explore:

- **Post-Impressionism.** Rejection of the emphasis the Impressionists placed on capturing light. Concerned with expression, structure and form. *Artists:* Vincent van Gogh, Paul Gauguin, Paul Cézanne and Henri de Toulouse-Lautrec.

- **Fauvism.** Characterized by intense, unnatural colors and nonrepresentative values that flatten forms. Because their colors were seen by many as violent, artists in this movement were known as "the wild beasts." *Artists:* Henri Matisse, Raoul Dufy, Maurice de Vlaminck and André Derain.

- **Cubism.** Subject matter is broken up, analyzed by the artist and then reassembled in a nonrealistic form. *Artists:* Pablo Picasso, Georges Braque, Marcel Duchamp and Juan Gris.

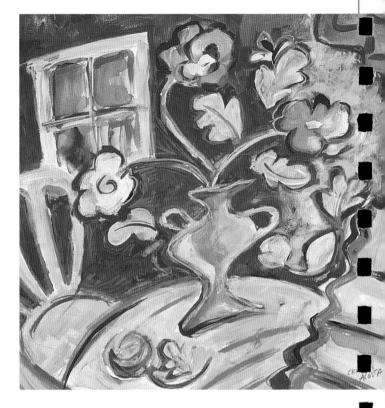

- **Abstract Expressionism.** Painting with a spontaneous, gestural approach to show feelings and emotions and to release the creativity of the unconscious mind. *Artists:* Jackson Pollock, Willem de Kooning, Hans Hofmann and Joan Mitchell.

The artists in these groups endured a great deal of criticism to pave the way for the freedom in painting that we now take for granted. This book

Expressing Emotion

Many internal-focus artists enjoy expressing emotions. Cristina Acosta observed the enthusiasm and fun experienced by her young daughter as the child painted, and she wanted to capture that level of pleasure in her own painting. The essence of joy, not the details of the scene, is the subject of *Breakfast Bouquet*. She expresses these feelings by using bright colors and swirling strokes, supported by strong design concepts. Notice how she applies her mastery of the fundamentals of art and painting to express her inner visions.

BREAKFAST BOUQUET | Cristina Acosta | Acrylic and pastel
22" × 22" (56cm × 56cm)

Literal Interpretation Does Not Always Capture a Subject's Essence

Artists often use abstraction or distortion to express moods and feelings because sometimes emotions can be better expressed in personalized, rather than realistic, forms. In fact, capturing the essence of your subject—its essential and unique nature—may be best accomplished by *not* painting it literally. A paradox in art is that by changing reality and enhancing its expressiveness, you can actually make things seem *more* real.

Capturing the Essence of Your Subject

Peggy McGivern uses extreme simplification and distortion to capture the essence of a child's joy at being whirled in a circle by a trusted adult. Note the enlargement of the adult's trunk and limbs. By taking this liberty with the proportions of the body, McGivern gives a solid, safe feeling to the figure, as well as portraying movement. How might the feelings expressed be different for the viewer if the subjects had been painted more realistically?

WHIRLYBIRD | Peggy McGivern | Oil
16" × 16" (41cm × 41cm)

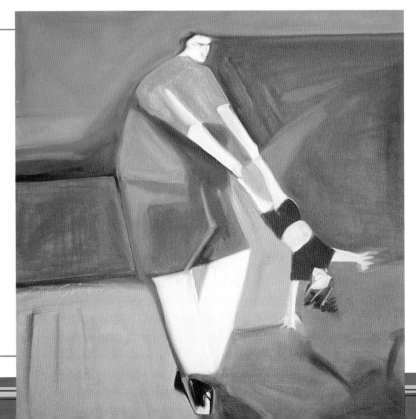

could not have been written (or at least few would have read it!) if the conventions of traditional painting had not been challenged and overcome.

This clearing of the art world of rules and restrictions freed artists to express what they felt or saw within themselves, rather than having to seek their inspiration from the physical world. Although artists may use physical objects to represent what they see in their mind's eye, their purpose is usually to express the intangible, such as a feeling or an idea. *Subjective*, meaning produced by the mind or resulting from feelings, is another term to describe internal focus. Picasso, describing his subjective approaches, has been quoted as saying, "I paint things not as I perceive them but as I conceive them."

Like Picasso, the Surrealists were internally focused, interested in depicting their dreams and accessing the content of their subconscious minds. Sometimes they used known forms in unorthodox ways, but their intention was not to create works that were logical or obvious in meaning. Salvador Dali, for example, painted the limp watch faces he encountered in his dreams to symbolize the mystery of time. Marc Chagall is a famous Russian artist who created mystical floating figures to portray his dreams and desires. As a storyteller, he often painted images that reflected his Jewish heritage and childhood memories.

"I would like to write the way I do my paintings, that is, as the fantasy takes me, as the moon dictates ..."

—PAUL GAUGUIN

Idealizing Your Subject
Vince Gasparich creates a mystical, stylized and idealistic world through his paintings as a reaction against the sometimes ugly realities he encountered during his years as a news photographer. He uses outlines around the clouds, which we know don't appear in nature, to express the magical time at night when clouds and landscape are visible as silhouettes against a starry sky.

WELCOME HOME | Vince Gasparich | Oil pastel
18" × 26" (46cm × 66cm)

From Visual to Pure Expression

Connie Connally began this painting as she sat by a pond and studied the reflection of a barn. Near the water's edge was a stand of dead thistles which she saw as "thistle bones." When a wind gusted, the pink reflection of the barn on the surface of the pond was stirred into a swirling dance. That transformation inspired Connally, and her painting took on a life of its own. In her words, it "caught fire," and the resulting whirling image is a unique, personal expression of the scene.

THISTLES AND FIRE | Connie Connally | Oil
44" × 60" (112cm × 152cm)

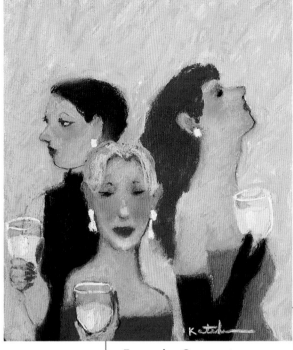

Expressing Commentary Through Images

Although this is a figurative work, it is not meant to be a representation of an actual scene. Rather, the artist is presenting us with people who are beautiful on the surface, but appear to be shallow and self-involved. The mood is satirical, achieved by the women's postures and facial expressions.

THE WHITE WINE DRINKERS
Carole Katchen | Soft pastel
20" × 16" (51cm × 41cm)

"With me, it's much more a matter of just accepting whatever happens, accepting all these elements from the outside and then trying to work with them in a sort of free collaboration."

—ROBERT RAUSCHENBERG

"My work is not about painting a picture, but about creating a painting. The scenes are just the catalysts for me to create works of art."

PEGGY MCGIVERN is a Denver-based artist who creates unique images using distortion and exaggeration. In this way she injects humor into her work and, at the same time, captures the essence of common reactions to the everyday scenes and events that make up our lives.

How did the exaggeration of shapes and forms in your work evolve?

Using exaggeration originally came from my desire for humor. I really can't think of anything better than having someone giggle when they look at my work. It's really fun and engaging for me to get the chaotic thing going. You can do great things making little swirly lines with brushstrokes.

How do you achieve your original approach?

I think what makes my work different is that I start out with a loose gesture line to get not only the shape, but also the movement of the thing. That's more intuitive—I'm just going with the flow. For me, it's in the mind and the movement. That's how I get elongated and exaggerated shapes. When I see an important point, which I call the "hero" of the painting, I switch and do a very detailed contour line. I can feel within five minutes whether a painting is going to work.

Have there been people who questioned your use of distortion?

Yes, because not everyone can deal with it. I actually had a workshop instructor pull my shoulders to try to "get me in line." He was a realistic painter who was also a perfectionist and couldn't deal with exaggeration. And this was just two years ago, after I had been a successful painter for years! Distortion has been in my work from the beginning. What works for me is the idea that "if God had wanted us to paint realistically, he wouldn't have invented cameras."

But I must add something here: I took the workshop to review the rules

Expressing Everyday Life
McGivern loves to catch life's everyday moments and express them with humor. Here she invented a scene that she felt conveyed how she feels first thing in the morning. Has she captured how mornings sometimes feel to you?

MORNING COFFEE | Peggy McGivern
Oil | 20" × 24" (51cm × 61cm)

about doing the body—like where the eyes and mouths are placed. Even in distortion, the basics need to be correct. And the fact is, although I fought it, I got a lot out of the workshop.

Your paintings really capture moments we've all had. I'm thinking of *Morning Coffee*, **for example, where you've captured that feeling of just not being ready to face the day by showing a person on the street in pajamas.**

Yes, my work is not about painting a picture, but about *creating* a painting. The scenes are just the catalysts for me to create works of art. And although I love to be silly, my work does reflect life's happenings. For example, I painted *Who Let the Cows Out?* during a period of personal loss when it seemed like everything I owned or cared about was flying out the window. During a happier period, I did a lot of paintings about nesting.

How do your approach to painting and your personality reflect each other?

Well, I tend to live my life a little chaotically, but then slow down to focus and reevaluate. I equate the chaotic phases of my life to my fast gestural marks on the canvas. The slower periods, when I'm more focused, are equivalent to the slow contour drawing of the "heroes" of my paintings. Even my garden looks chaotic (gesture), but then there is an area that is in perfect zen harmony (hero). I'm definitely a spontaneous person.

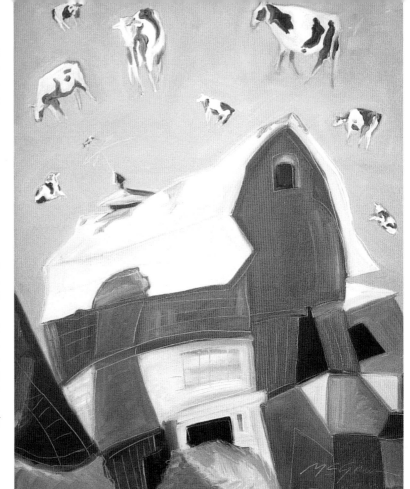

Expressing Feelings With Distortion and Whimsy

Here McGivern used escaping cows to express the chaos and confusion we experience when life gets out of control. Everything in the painting is highly distorted and out of proportion to give an unsteady look. The sense of chaos is reinforced by the fact that cows are normally docile creatures that follow each other back to the barn each evening after being out in the fields.

WHO LET THE COWS OUT? | Peggy McGivern | Oil 30" × 24" (76cm × 61cm)

WHAT COMES NATURALLY TO YOU?

An essential point to understand about artistic inspiration is that neither external nor internal focus is better. The important thing is to identify what is right for *you* as a painter. This is not always as easy as it sounds, as I have learned over time.

When I first started painting, I decided to be a plein air landscape artist because I was enthralled by the work of the Impressionists. But as I progressed, it became very clear that my passion was not engaged when I tried to paint what my eyes saw. Although it felt all wrong, I spent quite a few more years trying to follow my fantasy of how I thought I "should" paint. I didn't pay attention to my own inner voice.

I finally began to listen and realized that I didn't want to look outside myself for inspiration. Rather, I wanted my painting to translate my internal vision onto the canvas. I realized that plein air painting didn't suit me physically either, because I'm not a fast painter. I don't like to be rushed. I need time to process and solve problems, to feel my way through a painting, and to respond to an image as it develops. And I don't really want to stand outside, dealing with the elements while trying to paint!

Finding my way to my true source of inspiration was not a smooth journey. As human beings, we can be unwilling or even afraid to move away from the familiar. Even as I experienced the strong urge

Finding Inspiration From Your Surroundings

Lawrence Goldsmith (1916–2004) painted on location almost every day, but as you can see from this magnificent landscape, he had a strong inner voice. He did not try to copy the landscape as he saw it, but instead used it as motivation in his search for greater boldness. To quote the artist, "As a creator, you are seeking independence from the eye. What takes its place? The mind. Or the soul, if you like."

BURNING OFF | Lawrence Goldsmith | Watercolor
18" × 24" (46cm × 61cm)

to paint my internal vision, I found myself reluctant to paint less realistically and more expressively. The wise words of a dear friend, Barbara Stewart (1946–2005), helped me move past my hesitancy: "You must only paint what you feel. I don't think anyone taught Jackson Pollock to paint that way. I think you should be controversial." Although you may not wish to be controversial, choosing your direction as an artist by following your heart and honoring your passion will fill you with the divine joy of creativity.

Where Do You Fall on the Source of Inspiration Continuum?

There is a danger in writing a book about art because there are no universally accepted definitions, no hard and fast rules, and no strict divisions between styles and techniques. For example, in this chapter I distinguish between internal and external artistic inspiration. But the distinctions I propose are not black and white. They are part of a continuum, just like a value scale in which each shade of gray transitions into the next.

Every artist searches along the continuum to find a comfortable and expressive position. Instead of thinking, "Am I an externally or internally focused artist?" it is better to ask, "Where on the continuum is the natural place for me?" As you grow as an artist, you may find that you move along the continuum in one direction or the other. Artists, like their paintings, are works in progress.

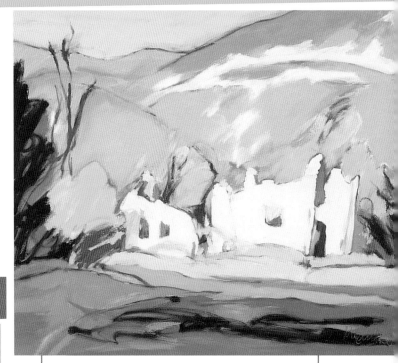

Making Reality Your Own
Madeleine Lemire exemplifies an artist near the center of the continuum. She is inspired by the physical world and says that she gets most of her ideas about what to paint while traveling and observing new sights: "The surprise and excitement of going to new places helps stimulate the imagination." Although inspired by the real world, Lemire uses colors and symbols from her imagination to capture the scenes she paints.

LES RUINES (THE RUINS) | Madeleine Lemire | Oil
30" × 36" (76cm × 91cm)

REVIEW AND REFLECT

QUESTIONS

1. Which paintings do you think were painted from what the artist was seeing in the physical world (external)? Which from the imagination (internal)? (Answers on page 28.)

2. Does it matter if viewers can tell whether the source of the artist's inspiration is external or internal? (Answer on page 28.)

3. What have each of the artists done to make their images, even those that appear to be based on their visual observations, more personalized?

4. How can knowing that artists have both external and internal inspiration and vary widely on the continuum give you more freedom to discover your own visual voice?

✎ WHAT SPEAKS TO YOU?

Check the boxes next to the paintings that appeal to you most.

- What is it about these paintings that appeals to you?

- What is it about the unmarked paintings that is less appealing to you?

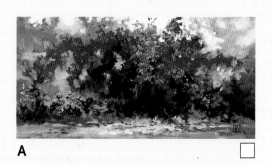

A ☐

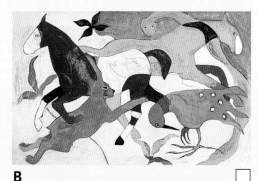

B ☐

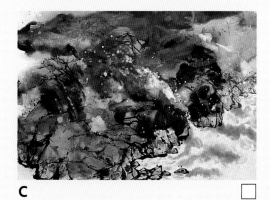

C ☐

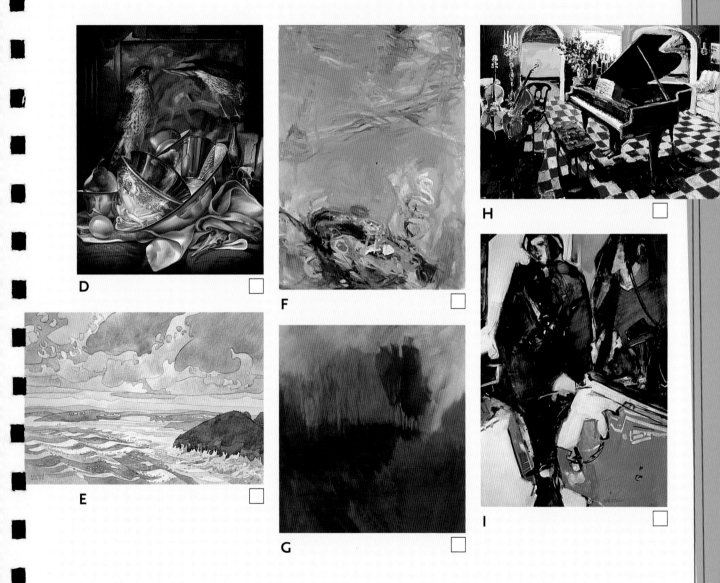

D

F

H

E

G

I

27

ANSWERS TO QUESTION 1

As you can see from the individual answers, these artists have both internal and external inspiration. As you talk with other artists and discuss their processes, you will find that most are inspired, to varying degrees, by both sources of inspiration.

A *Music in Red*, Bonnie Casey, oil, 15" × 30" (38cm × 76cm). Observed landscape form (external), then designed and subordinated rest of image to emphasize her strong emotional reaction to the bright red bush (internal).

B *Untitled*, Anne Embree, oil, 38" × 60" (97cm × 152cm). Visualized a variety of overlapping animal forms (internal), then carefully drew animal shapes based on realistic studies (external).

C *17-Mile Drive*, Lian Zhen, ink and Chinese paint, 16" × 26" (41cm × 66cm). Interpreted the scenic 17-Mile Drive in Pebble Beach, California. Used observation and photography (external), but then personalized the image from his imagination (internal).

D *That Which Is Revealed*, Nicora Gangi, pastel, 25" × 19" (64cm × 48cm). Researched and studied the scriptures for their intent and symbolism (internal). Then with this scripture concept in mind, she found objects that met her objective and set up a still life to paint from (external).

E *Nor'Wester at Hawk's Point*, Carolyn Lord, watercolor, 15" × 22" (38cm × 56cm). Painted on location (external), but used own unique vision to simplify and design the forms (internal).

F *Falling Away From Pink,* Connie Connally, oil, 90" × 70" (229cm × 178cm). Painted numerous references while observing the reflections of a pink barn in a pool of churning water (external), then later painted freely to capture her emotional response to the experience (internal).

G *Red Sky*, Linda Kemp, acrylic, 24" × 24" (61cm × 61cm). Kemp may have observed landscape forms on location (external), but she uses her own unique vision to express her emotional response to the subject (internal).

H *Cantina Cantata*, Robert Burridge, acrylic, 24" × 30" (61cm × 76cm). Painted from imagination (internal) in the studio. However, the artist drew on his extensive previous experience drawing and painting from life (external) in creating the realistic imagery.

I *Gallery Walk*, Carla O'Connor, gouache, 30" × 22" (76cm × 56cm). O'Connor painted and drew from a model (external), but clearly applied her own voice when simplifying and designing the forms (internal).

ANSWER TO QUESTION 2

I don't believe it matters if a viewer can tell whether an image has been externally or internally inspired. It is relevant only to the artist, who must be motivated in meaningful ways. When blocked from their natural sources of inspiration, artists cannot paint with passion. And it is this passion that communicates to the viewer, not whether the source is external or internal.

THOUGHTS ON QUESTIONS 3 AND 4

NOW IT'S YOUR TURN

EXERCISE 1
EXTERNAL FOCUS

Spend some time exploring your daily surroundings by intentionally and closely observing them. To the best of your ability, recall in detail places you have been. Write down the visual aspects you find especially attractive in your observations and recollections.

- What is it about these visual aspects that fascinates you?
- Do you feel drawn to create them in your art?

Choose a common object from your environment to draw or paint, such as a vase, a shoe or even your own foot. Reflect on how you *feel* as you draw or paint this object.

EXERCISE 2
INTERNAL FOCUS

Recall a dream, memory or emotion and create a drawing or painting that captures its mood, its meaning for you, or the feelings it brought forth. Attempt to create this work without judging what you are doing or why you are doing it.

When you are finished, write down how you communicated what you wanted to say in your drawing or painting. For example:

- Did you use color for its emotional impact?
- Did you use something in the physical world to represent your feelings?
- Did you create forms from your imagination?

Reflect on how you *felt* as you created your drawing or painting.

WHAT WORKS FOR YOU?

Review the images you created in exercises 1 and 2. Reflect on how you *felt* as you created each piece.

- Which focus, external or internal, engaged or excited you more?
- Did you find yourself more "in the zone" while working on one or the other?
- Which source gave you the most joy?
- Which seemed to free your artistic spirit?

Caution: Be careful that your internal critic doesn't drown out your true source of inspiration. For example, if you are more familiar with doing external-focus work, your head may rebel against doing internal-focus paintings. And the opposite may be true: the internal-focus artist may resist external-focus painting. Remember, this is a heart choice, not a head choice.

EXERCISE 3
RESPECT YOUR OWN VOICE

Georgia O'Keeffe was an internal-focus painter. She saw shapes in her head throughout her life, but ignored them and instead tried to paint in the ways that others encouraged her. One day in desperation, she reviewed all her work. She discovered that not one painting pleased *her*. Each one had been done to please someone else. At that moment she decided to paint in ways that would please her and she started by honoring the shapes she saw in her head. The result was a body of work that was uniquely her own.

Try this exercise for yourself. Take out all of your previous work. Which pieces please you most? Which did you most enjoy painting? Why? Was your inspiration external or internal?

2 DISCOVER YOUR SUBJECT MATTER

Choosing subjects to paint, just like identifying your source of inspiration, comes from within. I have always known I wanted to paint landscapes. I believe that this subject speaks to me because I love free, open spaces. Although I grew up on a farm, my adult life has been spent in cities. For me, landscapes represent freedom from the chaos and noise of urban areas and the demands of daily life. As an internal-focus artist, I don't paint actual landscapes that I see, but those I create in my mind. I never put people or structures in my landscapes, because I want them to be untouched by human presence.

"The creative mind plays with the objects it loves."

—CARL JUNG

What you decide to paint is a purely personal decision. No subject is better than any other. The important thing is to have a passion for and desire to paint the subjects you choose. For some artists, subject matter is arbitrary—it is the experience and process of painting that overrides all. You may even be among the artists who choose no subject matter at all. Some painters find joy in effectively using only the art elements: line, shape, color, value and texture, which will be discussed in the next chapter.

Do you find yourself interested in a variety of subjects? If so, allow yourself the freedom to explore them all! Experimenting with subjects to paint, like all other aspects of art, is part of a lifelong quest and contributes to the excitement of being a painter. In fact, this is one of the great things about being an artist: no matter how much you learn and how much you grow, there is always more. There's always a reason to get up each day to meet new artistic challenges!

Do you want to create art without a subject?

Do you see the beauty in everyday objects?

Do you want to capture the essence of a person or animal?

Are you inspired by the great outdoors?

HOW DO YOU PAINT YOUR SUBJECTS?

When people ask me what I paint, I know they want to know what subjects I paint. But if I reply "landscape," for example, I don't really answer their question. Landscapes can be very realistic, with the artist attempting to show as much detail as possible. Or, they can be simplified to mere bands of color that suggest the division of land and sky.

Abstraction refers to the process of painting your subject so that it differs from its natural, "real-life" appearance. It can be achieved through simplification or leaving out the details of the subject, or by distorting, flattening and changing the proportions or perspective. We saw abstraction in several examples in the last chapter, such as Robert Burridge's *Café Bouquet*, on page 15, in which he changed the perspective of the subject by tipping the table and vase of flowers forward. Abstraction is one way to bring out what you believe to be the real essence of a subject, which oftentimes makes it more universal, powerful and meaningful than if you painted it in a photorealistic manner.

Categories of Subjects

Subjects to paint have traditionally been divided into four categories:

- still life
- landscape
- figurative
- nonobjective (also called *nonrepresentational*)

32

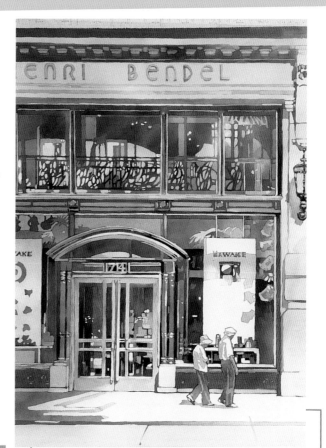

Realism Is in the Details
Jean Grastorf adds realism to the image by including many details: the building front with lattice work, store name, light fixtures and items in the windows. Adding the couple walking by gives the scene a real-life feel. Now, look closely; you'll see that, in spite of the realism, the artist has simplified the subject in a consistent manner and carefully selected the colors to create a harmonious and unifying design.

WINDOW SHOPPING | Jean Grastorf | Watercolor
28" × 20" (71cm × 51cm)

Abstraction Is Distilling the Essence
This landscape is abstracted down to bands of color, two trees and a barn. The detail has been removed, but there is no difficulty in understanding the image. This degree of simplification is not easy because it requires a strong design and careful choice of colors to make an interesting image without relying on detail.

THE RED BARN—RUTHERFORD | Leslie Toms | Oil
12" × 12" (30cm × 30cm)

Constantin Brancusi, a sculptor, gave a wonderful explanation of the intention of abstraction: "When you see a fish, you don't think of its scales, do you? You think of its speed, its floating, flashing body seen through the water. Well, I've tried to express just that. If I made fins and eyes and scales, I would arrest its movement, give a pattern or shape of reality. I want just the flash of its spirit."

In a sense, every painting is an abstraction because you are transforming a three-dimensional subject into a two-dimensional representation. But there are various *degrees* of abstraction, from interpretations of realism to very personalized presentations of subjects. The use of abstraction is one way to make your work your own. As you look at the images that follow, which progress from realistic to more abstract within each subject category, consider how and why each painter chose to use abstraction.

"There isn't a person, a landscape, or a subject that doesn't possess at least some interest—although sometimes more or less hidden. When a painter discovers this hidden treasure, other people immediately exclaim at its beauty."

—PIERRE AUGUSTE RENOIR

STILL LIFE

Still life is defined as an arrangement of objects that do not move. Still-life subjects are often represented outside their natural environment and they sometimes contain unusual combinations of items. A still-life scene is often set up with its own lighting, but this is not always necessary. Examples of still-life subjects include flowers in vases, fruits, vegetables, bowls and toys. Less conventional still-life objects include instruments and tools, kitchen utensils and personal objects, such as a comb and brush set.

Instructors often use still-life setups to teach painting, because the arrangements do not move or change and therefore can be studied and

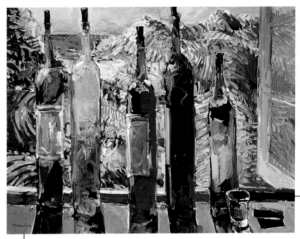

Abstracting the Background
Burridge has created an abstracted landscape as a backdrop for colorful bottles. Although the landscape is far from realistic, the shapes and brushstrokes suggest flowing land forms. Are you interested in creating impressions rather than strict, literal renditions of what you see?

BY THE BEAUTIFUL SEA | Robert Burridge | Acrylic
30" × 48" (76cm × 122cm)

Portraying the Light
This painting represents a high degree of realism. Davis faithfully portrays the effect of sun illuminating the flower. Can you see how the attention to subtle value and color changes adds to its realism? Does trying to capture the effect of light on a subject in this way appeal to you as an artist?

ENLIGHTENMENT | Brian Davis | Oil
30" × 24" (76cm × 61cm)

painted over a long period of time. Still life can be especially appealing to painters who enjoy taking their time when painting or are happiest when they can "tinker" with a piece, making changes here and there. Objects can be arranged to tell stories.

For example, Robert Burridge's *Adventures in Bobland* (see page 36) is a type of self-portrait in which the artist has painted a variety of objects that have personal meaning. Nicora Gangi arranges objects to represent the meaning of biblical passages (see page 80).

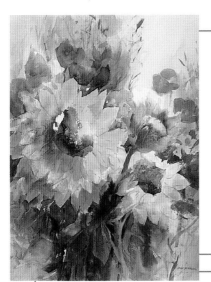

Capturing a Subject's Essence
Compare this painting with the one by Brian Davis on page 34. McKasson has abstracted the flowers by painting them loosely and with little detail. But notice how she creates a sense of depth by using more detail and warm colors to visually move the closest flowers forward and then cool blue tones to cause the background to recede. To achieve success with abstraction, artists must have the ability to capture the essence of their subjects even as they simplify them. Is the loose painting of forms and colors more exciting to you as an artist than re-creating details?

SUNLIT SUNFLOWERS | Joan McKasson | Watercolor
26" × 20" (66cm × 51cm)

Expressing Ideas Through Abstraction
This is a highly abstracted still life by Joan McKasson. The cat image was inspired by a sculpture owned by her son, who was due to arrive home soon from the Peace Corps in Uzbekistan. Combining images of home and the country in which he served, McKasson placed Ryan's wooden cat against a background of the cotton crops seen in the Uzbek landscape. The dark sky creates a sense of mystery. Do you like the idea of expressing emotion in your paintings by using meaningful personal objects? Do you have ideas you believe you might best express through abstraction?

WAITING FOR RYAN | Joan McKasson | Watermedia
30" × 22" (76cm × 56cm)

"When I use objects, I see them as a vocabulary of feelings. I can spend a lot of time with objects, and they leave me as satisfied as a good meal."

—JIM DINE

35

RBurridge

"Never paint a subject because you think it's going to sell. Paint what's in your heart and you'll be all right."

PHOTO BY J. FREDRIC MAY

ROBERT BURRIDGE left a successful career in advertising and industrial design to become a full-time painter. His energetic, spirited style shines through all his work, including the still lifes he now paints from imagination and which contain objects he loves or that represent things he likes to do when he has the time.

Do you have a favorite still-life subject to paint?

I don't limit myself on subjects. I paint what's in my heart. I truly only know my heart. I listen to it and it steers me in the right direction. I only paint things I love, things that interest me. Every morning I paint small images that I call my "little gems" as a warm-up exercise. These are usually still-life subjects—things such as fruits, coffee cups, vegetables, wine bottles and florals.

I also paint places I'd like to be—if I had the time—a big red comfortable chair, luscious landscapes. I use symbolism to express myself in my work. Right now, I'm really interested in Egyptology and fascinated by what the ancients were able to do by candlelight. I'm trying to bring that into my paintings.

Are there limitations or problems posed by your subjects?

There aren't any limitations for me. It's not part of my vocabulary. I never see things as problems, but as opportuni-

Painting Joyfully

The artist's delight in painting this subject is apparent and contagious. He joyfully painted all his favorite Bob-things without worrying about realism: food, wine, paintings, art materials, music and even his favorite pet cow that peeks into the studio on occasion to see what he is doing.

ADVENTURES IN BOBLAND
Robert Burridge | Acrylic
43" × 71" (109cm × 180cm)

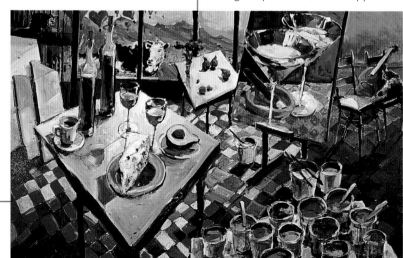

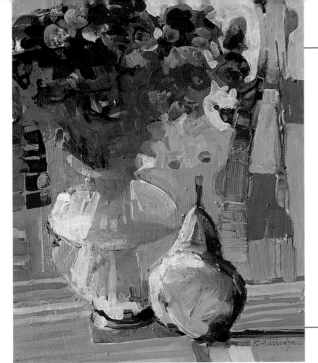

Enlivening a Still Life

Here we see a still life with a slightly abstracted but recognizable vase of flowers and a pear sitting on a tabletop. The convincingly full-bodied forms of the vase and pear are differentiated from the background primarily through their implied volume. Both the still-life objects and the background are painted texturally in vibrant color and pattern, but the background recedes almost magically due to its flatness. The activity of the background adds interest and variety without defining specific objects or competing with the objects in the foreground.

SOLARIUM | Robert Burridge | Acrylic and oil
20" × 16" (51cm × 41cm)

ties to seek creative solutions. I loved learning to think in art school. They would throw out these very cerebral problems and we had three hours to solve them.

What advice would you offer the readers regarding their choice of subject matter?

Never paint a subject because you think it's going to sell. Paint what's in your heart and you'll be all right. Stop listening to people who give you advice, but who can't do what you're doing. Surround yourself with people who support you and support your dream.

How has your work evolved over time?

A quote I love is that "it's never too late to be what you should have always been." I had classic training in art school and then worked as an industrial designer. Twenty years ago I decided to follow my heart and become a full-time artist. When I first started, I worked at a drawing board and painted very tightly, as I'd been taught. My art looked like everyone else's. Well, I didn't want to look like everyone else. About that time I saw a photo of Matisse drawing with a ten-foot (3m) stick. I ran out and put my brushes on branches. I now extend all my brushes and paint three or four feet (91cm or 122cm) from the canvas. The idea is to stay loose. The brush extension also lets me see the overall work as I paint.

I'm doing anything I possibly can to break away from my classical training. I do everything the opposite of how I was taught! I'm also using simpler forms in my paintings.

What is your current working method?

I start by making a giant mess on the canvas. There's no focal point or anything. Then I pull images out. I think to myself, "I know there's a pony in there somewhere!" I'm an abstract neo-expressionist, so I really like painting stories and their symbolic images. And I believe that if it's worth exaggerating, it's worth over-exaggerating!

I'm still very concerned about value, color—that kind of thing—although I'm more concerned about the quality of the painting, its content and its thematic features. For me, art is the highest form of hope and faith in good things to come.

37

Bringing Life to Still Objects

Robert Burridge | Burridge is a studio painter who paints images of things and places he loves. He uses an all-over approach as he works, continually refining the composition and its components. This method of working is illustrated in the steps he followed in creating *Café Beaujolais*.

MATERIALS

Surface
30" x 24" (76cm x 61cm) Masterpiece Artist Canvas (2 ½" [6cm] 3-D Masterwrap)

Brushes
No. 6 round • no. 8 flat • no. 10 filbert

Acrylic Paints (Holbein Acryla)
Cadmium Green Light • Cadmium Red Middle • Cadmium Yellow Light • Cadmium Yellow Orange • Cerulean Blue • Cobalt Blue • Compose Blue 1 • Compose Rose • Cyprus Green • Katsura Blue • Marigold • Orange Red • Oriental Green • Peacock Blue • Titanium White • Ultramarine Blue • Violet • Yellow

Other
Orange gesso (Holbein) • Golden Polymer Varnish with UVLS

1 Plan the Darks and Start Loose
I start by painting with orange the areas that, at this point, I plan to place in shadow. These will be the darkest values. After this dries, I do a loose wash sketch using red and Titanium White.

2 Design Considerations
I strengthen the design layout by painting the darkest areas a purer red tone. This includes the background, too, because this simplifies the area and helps to maintain the color harmony. I continue developing the composition by adding a second wine glass and small fruit on the left side of the table. I also start to define the sky shapes.

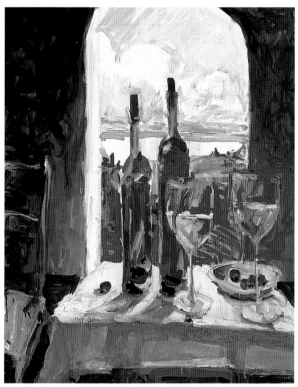

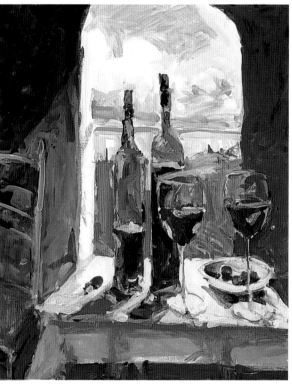

3 Choose a Dominant Temperature

At this point, I decide I want a cooler painting, so I switch to thinned layers of a cool blue around the focal point of the red wine glasses. I also decide to add a chair to keep the viewer's eye within the frame.

4 Develop the Darks and Contrast

I add the darkest darks and kick up the contrast by adding green in the bottles, deeper red in the glasses and red to the chair.

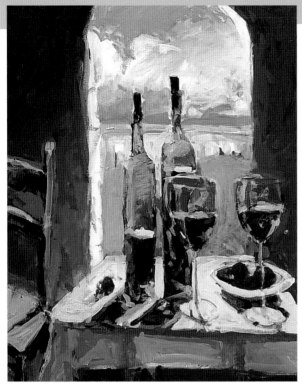

5 Punch Up the Color and Maintain the Focus

The painting needs some finishing "*wow*" color, so I add orange to the sky and behind the green bottles. I really just want to play with placing warm and cool colors next to each other. I add the orange to both the foreground and background to keep the painting pulled together. I also see that I need to tone down the red chair to draw the eye back to the center of interest.

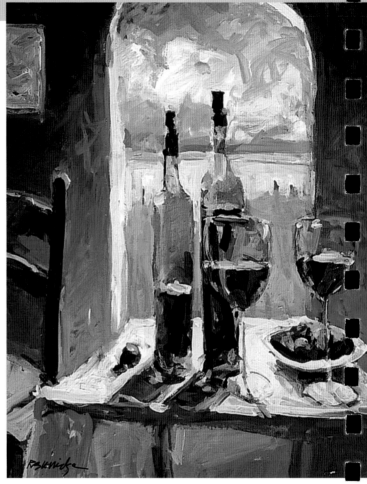

6 Unify With an Overall Wash

Finally, I add a cool wash to tie all parts of the painting together.

CAFÉ BEAUJOLAIS | Robert Burridge | Acrylic
30" × 24" (76cm × 61cm)

LANDSCAPE

Although landscape painting usually brings to mind the depiction of natural scenery, it often includes anything that is seen or painted outdoors, such as architectural structures and other man-made objects. Cityscapes, seascapes and pastoral scenes are all considered to be within the broad category simply referred to as *landscape*.

The resurgence of plein air painting in recent years has increased the popularity of landscape painting. A major impetus for painting on location for some artists is the desire to record natural settings before they are built on or paved over. Other artists love the hustle and bustle of the city and want to capture the feeling of our busy contemporary world, while still others enjoy painting the juxtaposition of the natural and the man-made.

Points to Ponder

The landscape paintings shown here progress from realistic to abstract, just as the still-life images. As you look at the images:

- Think about what the artist accomplishes through abstraction.

- Try to imagine yourself in each setting. What feelings does each scene evoke in you?

- Do you find it inviting? Does it look like a place you would like to visit?

- How do you think the artist felt while painting the scene? Are you drawn to such an experience?

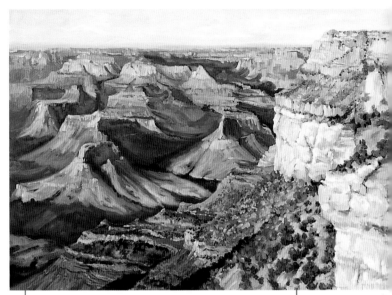

Using Perspective to Create a Realistic Effect
This is a realistic depiction of the Grand Canyon. The peaks, shadows and foliage can be identified easily. Perspective, in which the artist makes the formations smaller, less detailed and bluer as they recede, is used to enhance the feeling of great depth. Are you interested in creating a sense of deep perspective in your landscapes?

GRAND VIEW | Bonnie Casey | Oil
30" × 40" (76cm × 102cm)

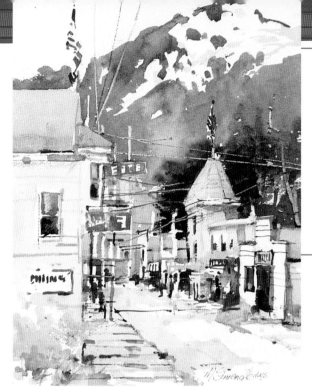

Using Simplification

This street scene is somewhat realistic, but Marilyn Simandle has simplified the buildings and mountain range. The structures in the distance are suggested by shapes and values, rather than by relying on detail. Notice how the overall cool tones suggest the winter season. How might the colors have been different if the artist had painted the scene in the summer?

ALASKA | Marilyn Simandle | Watercolor 12" × 9" (30cm × 23cm)

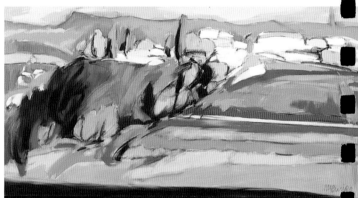

Suggesting Your Subject

Lemire has abstracted an entire hilltop town to white blocks with a few red lines. The theme of simplicity is carried through in the use of primary colors. Although minimally stated, the mountain, cliff, hillside, foliage and town are all easily identifiable. Isn't it amazing how little information we actually need to define a scene? Look around your own outdoor environment. Are there scenes you might be interested in abstracting by using simplification?

LES RESTANQUES (THE SLOPES) | Madeleine Lemire | Oil
30" × 60" (76cm × 152cm)

"... the works I do are a mixture of ideal situation in shape and spontaneity reacting to landscape and a feeling of evoking how I feel, myself bodily, in relation to this landscape."

—DAME BARBARA HEPWORTH

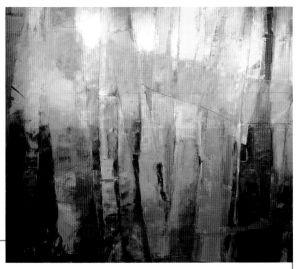

Abstracting With Color and Shape
In this highly abstracted painting, Barbara Rainforth uses shape and color beautifully to suggest a streak of light moving through a stand of trees. She has both simplified and fragmented the shapes in the landscape. How are you affected by the warm colors and slivered shapes?

FOREST LIGHT | Barbara Rainforth | Oil
78" × 91" (198cm × 231cm)

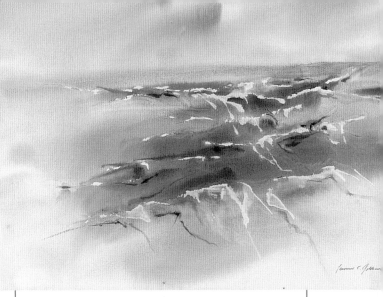

Creating Beauty With Brushstrokes
Goldsmith effectively captures one of the many moods of the sea, this one on an overcast, stormy day. Using a limited palette and with just a few brushstrokes, he has caught the energy and force of ocean waves. A master of advanced watercolor techniques, Goldsmith laid down colors and then went back and lifted them out to leave the ragged white areas that communicate so much to the viewer about the action of the waves.

CHOPPY WATERS | Lawrence Goldsmith | Watercolor
18" × 24" (46cm × 61cm)

"In front of Monet's twenty views of the building, one begins to realize that art, in setting out to express nature with ever growing accuracy, teaches us to look, to perceive, to feel. The stone itself becomes an organic substance, and one can feel it being transformed as one moment in its life succeeds another."

—GEORGES CLEMENCEAU
on Claude Monet's series of paintings of Rouen Cathedral

c.m.lord

"Quite often my subject matter is a reflection of my life—what's going on for me at the time."

PHOTO BY NAN PHELPS

CAROLYN LORD lives in northern California. She paints watercolor landscapes on location, often using an approach that links shapes to create form and mass, light and shadow.

Do you have a favorite landscape subject?

That's a hard question. I think that beauty is my subject, things that capture my attention. I may see a piece of equipment at a construction site while driving my carpool. Or I'll notice a pile of gravel. It's not so much the object itself, it's more about color and light. I once painted some shipping containers that were an amazing blue, arranged in an orderly way.

Whether it's a sunny or overcast day determines how I paint and create the composition. I'll place things differently depending on whether there's light or shadow. On overcast days, it might be about texture, pattern or local color that creates the design. On a sunny day, the way the shadow shapes move across objects in the painting becomes the defining structure of the design. The humidity of the day and how quickly the paint dries on the paper affect the process and final look of the painting.

How did you know which subject matter was right for you?

When I was in college, my painting instructor was waxing poetic about a particular old building in the village. After painting there a few times, I realized it just wasn't me. During that quarter I also did some garden paintings. It was the first time I had done flowers as the center of interest. I felt, "This is great." I thought to myself, "This feels like my work." We all have our own niche in eternity, and it's about finding our own niche.

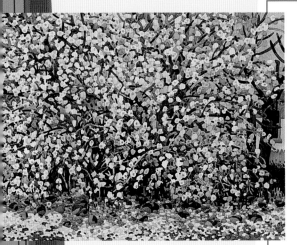

Filling the Canvas With Your Subject

There is no doubt what Lord was interested in capturing in this painting. You can almost feel the visual excitement the artist was experiencing as she painted the profusion of blossoms on the tree and in the foreground, filling the entire picture plane with this outrageous display of nature's beauty.

ALMOND PETAL FLURRIES
Carolyn Lord | Watercolor
22" × 30" (56cm × 76cm)

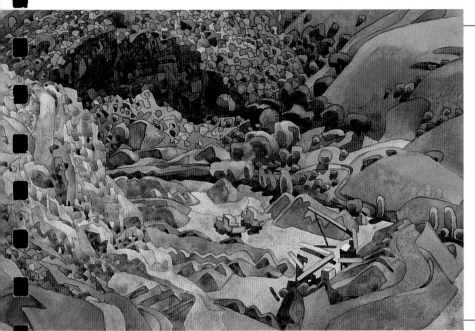

Making the Ordinary Extraordinary

In this painting, Lord has taken an ordinary rock pit and turned it into a visual delight. Note how she has used a usually ignored scene and created a patterned design that is fascinating to look at. Her title, taken from her son's favorite flavor of ice cream, reflects her sense of humor. As you survey your everyday surroundings, consider looking for possible subjects.

MINT CHIP ROCK PIT | Carolyn Lord
Watercolor | 15" × 22" (38cm × 56cm)

How does the subject matter serve what you want to say in your paintings?

Quite often my subject matter is a reflection of my life—what's going on for me at the time. I'm a homebody with a little garden that I like to paint, as well as the view down the street and scenes in my neighborhood. Once we had an exchange student from Brazil. He liked Pink Floyd's "Dark Side of the Moon," and I painted a melon and egg with the light coming from behind, like a new moon, and named it *Dark Side of the Melon*. My work contains little hints from my life, what I'm thinking about. Sometimes it's very obvious what is consuming my time. When my son was an infant and toddler, all I did was draw and paint him.

Do you feel there are any limitations on what someone paints?

It is not the subject matter, but how it is handled that is the key to whether it is just another painting or a work of art.

How has your work changed over time?

My old way was to literally paint each petal of a flower and paint in layers. I made sure they matched in color and value even as I painted each one individually. Now I paint the flower's silhouette, then go back and add details. There is an irony here. I learned strong drawing skills in my college art classes during a time when abstract expressionism was popular, and when I graduated in 1978 some people, when they met me, told me that they thought I was thirty or forty years older because of my academic style. Since then, the pendulum has swung the other way; I have loosened up, but now the trend is toward classic realism, so I'm too loose!

Personalizing a Landscape

Vince Gasparich | Gasparich combines line, shape and color to create unique landscapes. This one is not of a particular place but is actually made up from parts of many different places in northern New Mexico. "As I travel around the state I often take pictures and I'll go back to those photos for inspiration, but all of my paintings are drawn from memory," Gasparich says. "By not painting on location or from photos, my imagination is set free to create my own idealized view of the world. The fine details disappear, and the stronger, simplified shapes are what stick in my mind."

MATERIALS

Surface
18" x 17" (46cm x 43cm), 98-lb. (208gsm) Canson Mi-Teintes paper

Brushes
Assorted Grumbacher bristle flat and bright nos. 6 to 12

Acrylic Paints (Golden)
Cerulean Blue Deep • Chromium Oxide Green • Hansa Yellow Medium • Pyrrole Red • Titanium White

Oil Pastels (Sennelier, Holbein and Van Gogh)
Bartyle Green • Chrome Yellow • Cobalt Violet Light • Gold Yellow • Iridescent White • Mandarin • Oxide of Olive • Phthalo Blue • Red Violet • Rose Ochre • Ultramarine Blue • Vermilion

Other
No. 2 graphite pencil (for initial drawing) • Sanford China marker (used for outlining in the final painting)

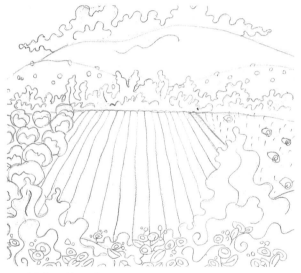

1 Make a Drawing

After working out the composition with thumbnail sketches, I draw the final image. This little valley and farm is like any number of farms that line the banks of the Rio Grande. The scene reminds me of late summer, when the air is still and the days aren't too hot. I wanted to portray that feeling of comfort and timelessness that a picnic on a lazy afternoon conveys. You're looking down into the valley framed in the foreground by wild sunflowers and twisted cedars.

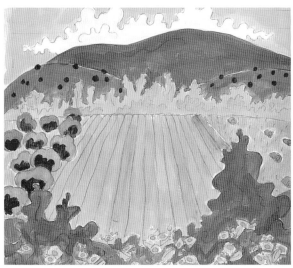 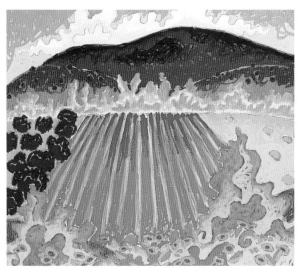

2 Lay In the First Layer of Color

I paint a quick wash of acrylic to start playing with different color combinations and to just get rid of the white of the paper. By using a warm palette of colors like Hansa Yellow Medium and Pyrrole Red, I feel the warm tones of the land will come through in the final painting.

3 Develop Color and Shading With Oil Pastels

The first layer of oil pastel is pretty loose. It sets the color foundation for the painting and helps me work out the shading for the different shapes in the overall landscape. I begin to see how all the colors in the painting will react to each other. I draw in exaggerated darks and lights that will later be blended together with a medium-tone color.

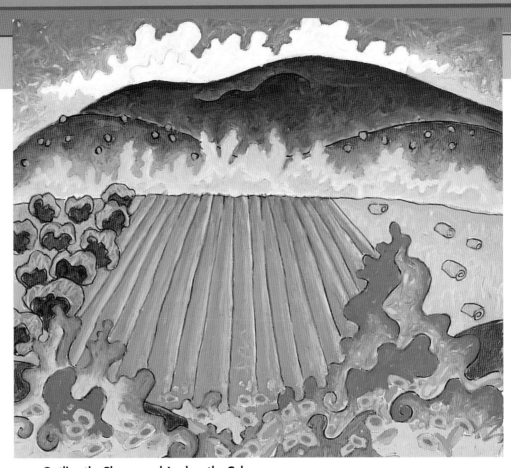

4 Outline the Shapes and Analyze the Colors

Next I outline the shapes in the picture with China marker and get a sense of what colors are working and which colors I want to change. I'm not liking how the greens are fighting each other. They need to be warmer and have more contrast. I also think the mountains could be a little darker so that the sky will pop. I really like the bales of hay now that they're outlined, and the squiggly lines of the foreground give the painting a lot of movement and energy.

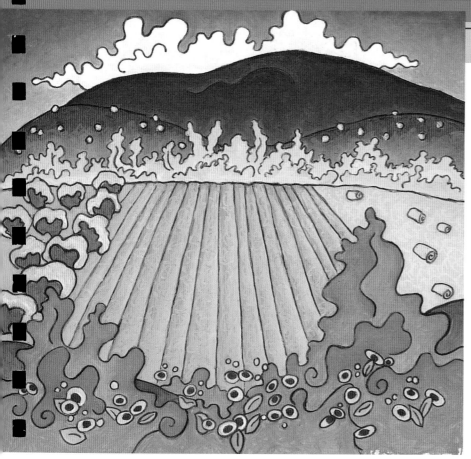

Detail
By making marks with Chrome Yellow over the green in the hay field on the right, I am able to both lighten and warm up the overall color while giving the field some nice texture.

Detail
I clean up the outline and darken the lines around major shapes, like the cedar bushes and sunflowers in the foreground, so that they all pop.

5 Refine, Redefine and Add Texture
To finish the painting, I further refine the colors with shading, add texture and redefine the lines to strengthen different shapes or areas. The outlining doesn't need to be perfect; in fact, I want the lines to be varied. I'll go over some lines to emphasize major shapes, but leave others a little smudged.

AFTERNOON PICNIC | Vince Gasparich | Acrylic and oil pastel
18" × 17" (46cm × 43cm)

FIGURATIVE

Figurative paintings contain forms of humans and/or animals as their major focus. Before the invention of cameras, painters were the recorders of history. They did realistic portraits because this was the only way to produce an image of their patrons. Since being liberated by the invention of the camera, artists have become freer to explore abstraction as a way to capture the essential characteristics of subjects.

This isn't to say that artists throughout history did not cleverly work in their personal feelings about their sitters. Francisco de Goya did a terrific job making a political statement by painting certain members of the Spanish royal family with foolish expressions on their faces! Other painters took the opposite approach and increased their commissions to paint portraits by idealizing their

Points to Ponder

As you look at the figurative paintings on these pages, consider:

- How the artists use composition, posture, facial expressions and degree of abstraction.

- What else they use to communicate meaning.

- What each artist accomplishes.

Is there something you wish to communicate through your work that might be achieved by using figures as your subjects?

Creating Mood With Details
Camille Przewodek presents this figure in a solemn, contemplative moment. The mood is intensified by placing the subject in a darkened room. The only glimpse we get of the outdoors is a gray stone wall. What would have been the mood and the meaning of this image if a sunlit landscape had been visible through the open door? Although the figure is painted in a rather realistic and straightforward manner, notice how the details of the costume of an exotic culture add a sense of intrigue to the work.

MONGOLIAN MEMORIES | Camille Przewodek | Oil
24" × 20" (61cm × 51cm)

Capturing the Moment

Many of us may have seen and ignored such an ordinary moment. But Casey captures it beautifully in this painting to present us with the love and camaraderie between horse and rider. She directs our attention to the young woman and her horse by painting them with the most detail, while abstracting the landscape to prevent distraction from the focal point. Painters make many choices in how they present their subjects in order to communicate their messages.

FEED BAG | Bonnie Casey | Oil | 24" × 12" (61cm × 30cm)

subjects, perfecting their features and making them look younger.

Just as with any other subject, figures give painters opportunities to send all kinds of visual messages. For example, you may choose a unique way to express an idea about an individual, humanity in general, or relationships that might encourage viewers to change the way they think. I recall an experience I had many years ago when I saw the work of a San Diego artist who painted the homeless people who populated her neighborhood. Instead of painting them looking dejected or with dark, somber colors as we might expect, she painted them in bright, highly saturated shades of orange. At the time, I was inexperienced with art and thought that perhaps she was unskilled and didn't know how to use color properly. I realized much later how naïve I was and how powerful those images were. They have remained with me over the years, which testifies to the impact of her work and the choice she made to bring attention, through the use of bright and arbitrary color, to a segment of our population that is often invisible to us.

The Figure Sets the Mood

A figure does not have to be painted in great detail, even if it is the main focus. What does the figure add to this painting? Even though painted simply, it has just enough form to show the movement of the body as it rows. When looking at this painting, I relate to the sense of tranquility, solitude and peace suggested by the rower. What does the scene suggest to you? How would the intent have been different if the artist had painted a group of racing scullers? Would the soft, subdued landscape still work with this change? Have you tried combining figures and landscape in your paintings?

BOATING ON THE RIVER | Rhonda Egan | Oil
11" × 14" (28cm × 36cm)

"The sight of a fine human figure is above all things pleasing to us ..."
—**ALBRECHT DÜRER**

Capturing the Personality

Connally has artfully captured the bulky presence of this breed of dog. The characteristic flat face, the stout body, and the large paws are all expertly painted in this portrait of a beloved pet. The background cloth is handled very loosely, but there is no doubt that this is Hanna's place.

HANNA | Connie Connally | Oil
18" × 16" (46cm × 41cm)

Creating an Exotic Scene

The woman depicted in this painting seems to be a goddess who walks the earth. Why do I see a female deity instead of male? One reason might be the feminine oval shape of the simplified face. If the jaw had been squared, it would have looked more masculine. When you are abstracting, attention to this sort of detail is essential to convey your meaning. Burridge intensifies the other-worldly atmosphere by using brilliant color and pattern in the background, as well as with the flowing robes and ornate headdress. The complexity and intrigue of this painting is enhanced by the mysterious birds and other life forms. What do you think the artist means by the title?

PUSHING UP THE SKY | Robert Burridge | Acrylic
60" × 42" (152cm × 107cm)

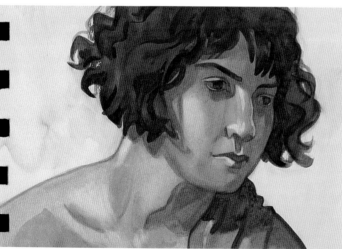

Giving Information Without Detail

The artist has chosen to greatly simplify the major shapes in this head and shoulders portrait. I find the treatment of the hair intriguing. Using little detail, Lord makes its thick curly texture evident to the viewer. Are you interested in conveying visual meaning through the use of shapes that are simplified, but exciting and varied at the same time?

SPRING DREAMER: MERAV | Carolyn Lord | Watercolor
15" × 22" (38cm × 56cm)

"What interests me most is neither still life nor landscape but the human figure. It is through it that I best succeed in expressing the nearly religious feeling that I have toward life."

—HENRI MATISSE

Carla O'Connor
AWS/NWS

"I've painted lots of subjects over the years, but I always return to the figure. It's not going back for me, it's circling around."

PHOTO BY PAT RUSH

CARLA O'CONNOR is a transparent watercolor and gouache artist who lives in the Pacific Northwest. Strong colors and bold brushwork that beautifully capture the essence of her subjects are the hallmark of her figurative paintings.

Do you have a favorite subject?
I consider myself a figurative painter. I've painted lots of subjects over the years, but I always return to the figure. It's not going back for me, it's circling around.

What are you working on now?
At this point, I'm concentrating on abstracts of the figure. In my mind, I have a goal of how I'd really like my paintings to look. I'm not there yet. I may never be there. Maybe it's not a good idea to have something in my head. Maybe it's better to just let images come rather than having a goal.

How did you know which subject was right for you?
I was classically trained in art. We didn't get to paint until our junior year of college. We drew every day from models. This became ingrained and it's just who I've become as an artist. I do try other things, like landscape, but I always come back to the figure.

What do you want to say in your paintings?
For me, it's pretty simple: I'm asking the viewer to share my particular vision. This is not always possible, of course. Sometimes I'll do a painting that means a great deal to me, and it's not important if others understand that.

Taking a Unique Approach
Most of us think of dancers in motion. Here O'Connor has chosen a moment of quiet reflection. The unusual angle of the model requires highly developed figure-drawing skills. Although the face is simplified and proportioned differently from what we are used to seeing, the image rings true. Are you interested in developing expert figure-drawing skills?

DANCER | Carla O'Connor
Transparent watercolor and gouache
30" × 22" (76cm × 56cm)

54

Using Details Innovatively

O'Connor has created a visual tapestry of design in this painting. You can see this if you follow the line of the chair edge as it wraps around the left arm of the model. Then she uses an unusual pattern on the model's legs. Doesn't this look like the wicker pattern of the chair? By integrating the model with the chair, she creates a unique image.

FERN | Carla O'Connor
Transparent watercolor and gouache
30" × 22" (76cm × 56cm)

How have your paintings evolved over time?

They have changed because I've changed. I can see it clearly. My experiences and the people in my life have an influence. I think this is normal. I was caregiver to my mother for ten years when she had Alzheimer's. During that time, I stopped making art. She died two years ago, and I just realized that I'm just now letting more color back into my work. I didn't even realize that those dark years caused me to do darker work. If your art is your vision of life, you won't always paint pretty pictures. I just let emotions flow through me, good and bad. Doing this I find I am more aware of joyful events and when I paint through the sadness it helps me feel better. It's like sharing the weight.

Do you feel there are any limitations to restricting yourself to figurative work?

No, I don't think so. What I have found in my own life is the pressure of time. I won't have enough time to paint everything I want to paint. When I find a subject, I may have many ideas for paintings.

What advice would you give readers who want to do figurative work?

I think you need the ability to draw. People are simply not being taught how to draw. You don't actually need to know the skeleton and muscles, but you have to be able to think and see in terms of shapes—this is drawing. Don't worry about being influenced by other artists, especially when you're learning painting techniques. But the important thing is to make the work your own so you can move on and not simply make copies.

55

NONOBJECTIVE

Nonobjective (also called *nonrepresentational*) paintings have no subject; that is, the painter is not trying to represent anything from the physical world. Rather, the artist's purpose is to create a work of art by using only the formal elements of art—line, shape, color, value and texture—to create a successful and expressive image.

Art that is not intended to "be anything" is problematic for many viewers. The natural tendency for the human brain is to organize images into recognizable objects. When we look at a nonrepresentational image, we search for something that looks familiar to us.

Years before I studied art, I attended an exhibition of nonobjective paintings. They seemed meaningless and I felt very angry about having wasted my time. My sister pointed out that the artist must have been quite skilled to have evoked such a strong emotional response from me. This made me curious, so I inquired about the artist

Points to Ponder

For some artists, having a recognizable subject is not important.

- Does it matter if the viewer can tell if a painting is abstract or nonobjective?

- If you painted an abstract image, would it be important to you that the viewer be able to identify your subject?

- Is it essential that others understand your intention?

- Does the idea of creating a painting without any subject at all appeal to you?

Developing a Unique Process

Shawn Snow creates a sense of beauty and mystery in his nonobjective work, which he describes as "an exploration and a learning process as much as it is an artistic endeavor." He is inspired by surfaces such as the patinas of metal, the tones and colors of rotting wood, and the grain of eroded stone. He says his pieces contain multiple levels of meaning that become entwined to form something greater than the sum of their parts. He glues down fabric, adds a white ground to it, blocks in the major forms and composition, and then layers and removes glazes until he finds the balance he seeks. Does this type of exploration without subject matter intrigue you as an artist?

EROSION OF ARCHITECTURE | Shawn Snow | Fabric, oil and alkyd
48" × 36" (122cm × 91cm)

and learned that he was a young man who had recently been confined to a wheelchair. His nonobjective paintings so effectively expressed his rage about his limitations that they reached my core. I could actually experience his anger.

Highly abstracted paintings are often confused with those that are nonobjective. In spite of all my study of art, I found it difficult to differentiate between the concepts of abstract and nonobjective until recently. To make matters more confusing, the word *abstract* is commonly used to describe works of art in the category of "I can't tell what this is." There is a difference among the artistic purposes and processes of abstract and nonobjective pieces. If the goal of the artist is to create a highly personalized image of a subject, then the work is abstract. If he or she is working with only artistic elements and has no physical subject in mind, the work is nonobjective.

Exploring the Square

Here, Grastorf explores the square shape and strong color. She uses painterly brushstrokes and smooth washes to achieve contrasts in texture. For her, working spontaneously with paint and collage is an exciting and creative way to improve her sensitivity to color, shape and value. She believes this reinforces the importance of having a strong underlying abstract structure whether she is painting realistic or nonrepresentational pieces.

SQUARES | Jean Grastorf | Mixed media
20" × 32" (51cm × 81cm)

Nonrepresentational or Abstract?

When I first saw this painting, I thought it was nonrepresentational. But when I read the title, the blue shape quickly became a canoe and the circular shape above it emerged as the moon. The secondary reddish shape to the right of the blue could be another canoe in profile. Burridge explains that he was inspired to simplify the subject matter to basic organic shapes.

DOCKING | Robert Burridge | Acrylic | 71" × 43" (180cm × 109cm)

"I usually begin each painting with a desired image quality in mind rather than a specific subject."

SHAWN SNOW is a New York artist who creates densely layered, nonobjective paintings. His painting process is as important to him as the finished work, and he constantly seeks fresh, unique visual effects as a means of expressing himself.

Have you always painted nonobjectively?
No, my roots are in doing representational work, especially figures. Over the years, I started extrapolating parts of figures and landscapes. I wanted to capture the essence of the subject without painting the subject itself. For example, to represent the human form I used lots of irregular shapes to achieve a sculptural feel. I was manipulating the shape of the working surface to give a *sense* of the human body, rather than just painting it. This was more real to me than painting a portrait. As a result, my work became more abstracted and dealt more with capturing the essence of the subject rather than simply illustrating it.

Was it difficult moving from representation to abstraction?
Yes, that initial jump took courage—more so than going from abstraction

Using Materials to Create Desired Effects
Snow started this piece by gluing down muslin on canvas and then priming it with oil. This gave the composition a sense of architectural form as he recalled an image he had worked with before and wanted to reinvestigate. He lightly glazed the surface of the oiled fabric to create the illusion of light. Can you see how his use of glazes allows light to penetrate the transparent layers and reflect back the colors and textures beneath, creating a jewel-like light that seems to shine from within the painting?

SEAMS | Shawn Snow | Oil and alkyd
48" × 36" (122cm × 91cm)

Knowing When a Nonobjective Painting Is Finished

This painting evolved through a long and labor-intensive process. Snow began the work by gluing down fabric in a fairly straightforward composition. He then spent months painstakingly adding layer upon layer of stains and glazes. After removing the color from the block in the center, the whole piece fell into place for him. When working nonobjectively, it is sometimes difficult for artists to know when a painting is complete and "right" for them: that point at which nothing should be added or taken away.

WARLORD | Shawn Snow | Oil and alkyd
48" × 60" (122cm × 152cm)

to nonobjective painting, which happened much later. At first, I needed to become comfortable working without a concrete image, which was quite difficult. I'm a drawing-based artist, so the hardest part was learning to use my drawing ability without relying on it as a crutch to resolve my paintings. Now I am more interested in using my drawing ability to create marks that activate the painting surface visually and tactilely.

How do you go about creating a painting without specific subject matter?

I usually begin each painting with a desired image *quality* in mind rather than a specific subject. For example, I will attempt to create a painting that looks like a plane of rusted metal or rotten wood. This is a loose, beginning inspiration and is usually revised during the painting process. Making paintings without an image pushes me to find other ways to create, and it is very rewarding when I find processes that work for me. Most of my pieces are done without a preconceived plan. As I create each one, it's a push and pull process to handle the mechanics of the painting, such as color relation and composition. I resolve each problem as it comes up, so it's more of an intuitive process rather than a specific order of operation. It is a very delicate balance, and I try to let each painting evolve individually and have a life of its own. In the end, the pieces either have a spark or they don't. If they do, then I will go on to exhibit them. If not, I will study them and learn from my mistakes.

What do you hope to communicate through your paintings?

The broad themes of my work are age, decay and history. That said, I like to appeal visually and emotionally to the viewer. So I try to make pieces that have a weathered beauty. Because there's no immediate subject matter, my paintings become more meditative and contemplative. I try to give the audience a painting that they can appreciate immediately through color and composition, as well as a painting that continues to reveal its subtle nuances for years to come. I create very dense paintings that still retain a serene quality. Overall, I find that people either love my work or they hate it, and I'm comfortable with that.

REVIEW AND REFLECT

QUESTIONS

1. Indicate which of these images you think are nonobjective. (Answer on page 62.)

2. In what ways has each artist abstracted his or her images? Look for distortion, simplification, flattening or change in perspective. (Answers on page 62.)

3. As you look at the images, do you respond more strongly to one type of subject matter?

4. Are you particularly attracted to any of the abstraction techniques used in these images? Which ones?

5. How does seeing the variety of ways in which artists personalize their paintings through abstraction give you ideas about expressing your own visual voice?

✔ WHAT SPEAKS TO YOU?

Check the boxes next to the paintings that appeal to you most.

- What is it about these paintings that appeals to you?

- What is it about the unmarked paintings that is less appealing to you?

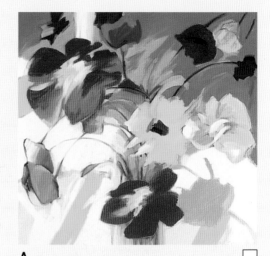

A ☐

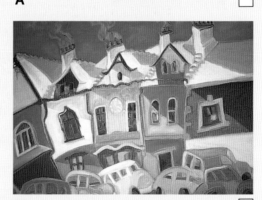

B ☐

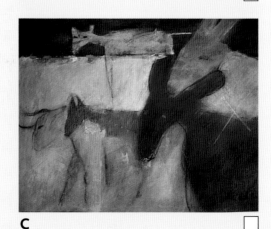

C ☐

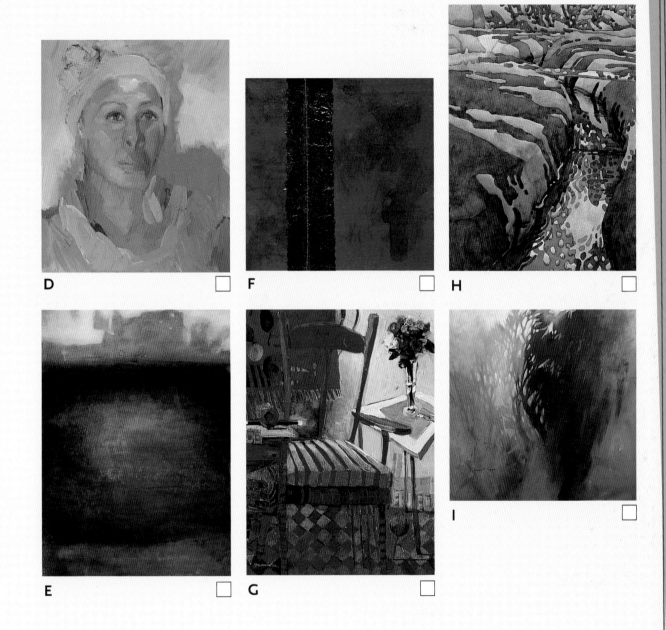

D

F

H

E

G

I

ANSWER TO QUESTION 1

Painting E is the only nonobjective work. The other one that may have confused you is painting F, but this is actually a landscape with an extreme abstraction of the Nile River in Egypt. As you can see, extreme abstraction and nonobjective work cannot always be distinguished without talking to the artist.

ANSWERS TO QUESTION 2

As you can see from the answers, most artists use abstraction to some extent.

A *Dans la Lumière du Matin (In the Morning Light)*, Madeleine Lemire, oil, 30" × 30" (76cm × 76cm). Simplifying and flattening the flower heads, vase and background along with intensifying the colors makes this a striking abstract still life.

B *Irish Rowhouses, Northern Ireland*, Peggy McGivern, oil, 24" × 30" (61cm × 76cm). Extreme simplification and distortion of perspective create the feeling of a cramped and very busy neighborhood.

C *Silence of the Night*, Anne Embree, oil, 32" × 40" (81cm × 102cm). This painting creates a wonderfully eerie mood through its distortion, especially of the large black animal with the unnatural blue eyes. The flat, simplified shapes enhance the ghostly feeling.

D *Mata Hari*, Cynthia Britain, oil, 12" × 10" (30cm × 25cm). Simplifying the background and details of clothing of the figurative work flattens the image so it connects to the background. This allows the focus to remain on the facial features.

E *Red Lake*, Shawn Snow, mixed media, 48" × 36" (122cm × 91cm). This image does not contain any subject matter. It is not an abstraction, but rather a nonobjective painting.

F *Kemet/Deshret No. 2*, Helaine McLain, acrylic and mixed media, 12" × 12" (30cm × 30cm). This landscape is created by greatly simplifying the Nile River in Egypt to just a suggestion of the water and land.

G *Magician's Chair*, Robert Burridge, acrylic/oil, 30" × 24" (76cm × 61cm). Tipping the surfaces of the floor, table and chair forward creates a flatter, more personal setting. The intensity of color increases the excitement and emotional impact of this painting.

H *Dixon's Ditch*, Carolyn Lord, watercolor, 15" × 11" (38cm × 28cm). Although painting on location and using accurate perspective, this artist emphasizes the abstract designs and patterns she sees in the landscape, resulting in a highly individual image.

I *In a Tangle*, Linda Kemp, acrylic, 24" × 24" (61cm × 61cm). Kemp creates a powerful sense of time and place by focusing on the essence of the image instead of the details. The abstraction of this piece is primarily in the simplification and flattening of forms and limitation of color.

THOUGHTS ON QUESTIONS 3–5

NOW IT'S YOUR TURN

EXERCISE 1
IDENTIFY YOUR PREFERENCES

The four categories of subjects are illustrated here and on page 64 in photographs taken by Laura Alexander. As you look at each one, listen to your internal voice and answer these questions:

- How do I respond to this image?

- Am I attracted to the subject?

- Is it visually appealing?

- Does it present artistic problems I am interested in solving?

- Am I interested in re-creating the subject or interpreting it in a painting?

- How would I paint it?

STILL LIFE

FIGURATIVE

LANDSCAPE

EXERCISE 1
CONTINUED

Note: Because the examples used for the nonobjective category are photographs, by definition they have a subject. The images are appropriate, however, because they express the essence of the image through the elements of line, shape, color, value and texture in the same manner as you would in creating a nonobjective painting.

NONOBJECTIVE

EXERCISE 2
WORK FROM REALISM TO ABSTRACTION

In doing exercise 1, you may have found that you have a preference for still life, landscape or figurative painting. Choose something from your preferred subject matter (not from a photo, but from life) to draw or paint as realistically as you can. Then, in successive images, abstract the subject until it is no longer recognizable.

- How do you feel about each of the images?

- Which painting is most expressive of your intent?

- Where in the realism-to-abstraction process did you hear your visual voice most clearly?

EXERCISE 3
DETERMINE WHAT TO PAINT

Ask yourself the following questions as you create a list of ideas for future paintings:

- **What do I love?** Recall the quote at the beginning of the chapter: "The creative mind plays with the objects it loves." How might you transform thoughts into paintings? Would you translate them literally, or represent them in other ways?

- **What do I know?** If you know something well, it may make a good subject for you. For example, Pierre Bonnard seldom left his home and immediate surroundings. He painted his home's interior, the surrounding gardens and the people he lived with.

- **What do I want to learn more about?** Drawing and painting something is a great way to get to know it well. For example, before trying to paint a tree, draw an individual leaf, the pattern of the bark, the way the branches divide, and so on.

- **Are there emotions I want to express or statements I want to make?** You can use objects to express them or try a non-representational approach.

EXERCISE 4
STUDY THE NONOBJECTIVE WORKS OF ARTISTS FROM THE PAST

Explore the images and interpretations of respected, established artists as you develop your own. Each of the following artists had a unique, original approach to nonobjective art. If you don't have access to the original paintings, find reproductions in books or on the Internet.

- **Mark Rothko** was a Color Field painter whose works consist of fuzzy rectangles of color floating on a monochromatic background. His intent was that viewers have spiritual experiences while meditating on his paintings.

- **Piet Mondrian** challenged himself to create a completely flat surface and limited his visual elements to black lines and blocks of primary colors (red, blue and yellow).

- **Jackson Pollock**, an Action painter, performed graceful, rhythmic movements that were captured in the paint he splashed and dripped onto a canvas placed on the floor.

- **Cy Twombly** wanted to express images of the unconscious mind with no conscious external references. His work is spontaneous and consists of free marks, lines and shapes.

- **Joan Mitchell** was a member of the Abstract Expressionist movement in which painters tried to evoke and express universal human emotions through abstract or nonobjective means. Mitchell, unlike others in this group, drew much of her inspiration from nature. Her spirited way of making brushstrokes is called *gestural* style.

EXERCISE 5
TRY NONOBJECTIVE PAINTING

A common misconception is that nonobjective painting is easier than representational. In many ways it is actually more challenging because the artist is limited to effectively using art elements without the references a subject provides. Carla O'Connor told me that she asks her students to create a good painting using only the art elements. "Now you don't have to make a horse or tree or flower. And they find this more difficult to do than painting a subject. Many people use the subject as a means of support."

Try creating a painting without a specific subject, using only colors, shapes, lines and textures in a pleasing, interesting manner. Then consider the following questions:

- Did you find yourself visualizing objects as you worked?

- Was it difficult to create art without a subject? If so, in what way?

- How did you feel as you worked on it?

- Was the experience satisfying?

3 DISCOVER YOUR ART ELEMENTS

Art elements are the tools painters use to give expression and form to their visual voice. When you get right down to it, all paintings can be reduced to the art elements. What else is a painting if not some combination of line, shape, color, value and texture? Although artists vary in their opinions about the exact names and numbers of the elements, we'll focus on the five mentioned above, which I believe cover all the available visual tools.

Most artists emphasize more than one element in a painting, but not all five. Placing equal emphasis on all five would lead to a breakdown in the structure of the image. The result would be overwhelming for the viewer. To make a strong statement, painters must make decisions about which elements to emphasize to most effectively communicate their message.

An amazing thing about art is the variety of ingenious ways that painters are able to combine only five basic elements to create work that is their own. The combinations are endless, and making your own choices about which to use—and when to use them—will offer you many exciting and interesting painting challenges.

"I found I could say things with color and shapes that I couldn't say any other way— things I had no words for."

—GEORGIA O'KEEFFE

LINE: Are you a straight shooter?

66

COLOR:
Are you a music maker?

VALUE:
Are you a plan fan?

SHAPE: Are you a shape maker?

TEXTURE: Are you an entertainer?

SPEAKING THE LANGUAGE OF LINE

I love this quote by Paul Klee: "A line is a dot that goes for a walk." Like a person out for a stroll, a dot on a page can move in a variety of directions: vertical, horizontal or diagonal.

In a painting, directional lines communicate different messages.

- *Vertical lines* communicate stability and strength. Think skyscrapers and tall forests.

- *Horizontal lines* connote serenity. Think oceans, meadows and reclining figures.

- *Diagonal lines* convey activity, energy and movement. Think jagged mountains and leaning structures.

"Everyone knows that a single line may convey an emotion."

—PIET MONDRIAN

Inventing Lines to Create Effects
Gasparich invents lines in his landscapes that certainly do not appear in nature. How would the feel of this painting be different if he had not used lines to separate the color fields and define the foliage? Does this use of line appeal to you?

SPRING | Vince Gasparich | Oil pastel
12" × 12" (30cm × 30cm)

Leading the Eye With Implied Lines
Lemire uses the white foliage of the almond trees as a solid mass to create an implied, directional line leading the eye to the buildings. She uses actual lines to define the edges of the structures. Do you like the soft look of implied lines? Have you used implied lines in your paintings?

LES AMANDIERS (THE ALMOND TREES) | Madeleine Lemire
Oil | 38" × 54" (97cm × 137cm)

> *"Note how a line takes hold.*
> *It hooks the vital parts together.*
> *It binds the composition."*

—ROBERT HENRI

The ways in which lines change direction—whether they progress in a straight, meandering or zigzag manner—also communicate different messages. Imagine how a gentle rolling hill would be depicted as opposed to a jagged steep mountain.

Lines can be used to connect the disparate parts of a painting to create a harmonious whole, or to separate a piece into various components. Lines can create a sense of depth when thicker ones are used in the foreground and thinner ones in the background. By reversing this usual practice, images can be flattened for interesting effects.

Lines do not have to be drawn, but can be implied. For example, shapes, colors, values or textures placed so that they lead the eye in a given direction can create an implied line.

Using Lines to Create Movement
Simandle focuses on lines and makes them an integral part of this subject. The title seems to indicate that they are what originally caught her artist's eye. Place yourself on that dock and think about the motion of the boats moored there. How do the lines help the viewer to feel the movement of the water? Would fewer lines have the same effect?

NETWORK | Marilyn Simandle | Watercolor
24" × 36" (61cm × 91cm)

Defining Subject Matter With Lines
Lord describes the scene with a profusion of lines, including the ground, tree foliage and shadows. Notice how the lines animate the surface of the painting.

LIVERMORE ROAD RANCH HOUSE | Carolyn Lord
Watercolor | 15" × 22" (38cm × 56cm)

MAKING STATEMENTS WITH SHAPE

A *shape* can be defined as a closed line. It may be *biomorphic* (curved) or *geometric* (straight). You may encounter artists who distinguish between shape and form, explaining that a shape is two-dimensional (having height and width) and a form is three-dimensional (having height, width and depth). Implying three-dimensional forms on a flat surface is challenging, so their representation in a painting requires technical skills and knowledge of

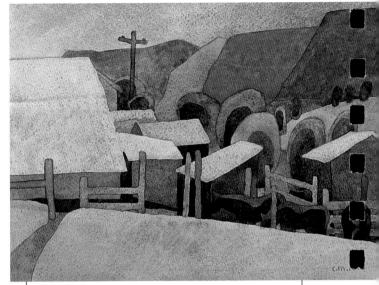

Simplifying Scenes to Their Key Shapes
Lord has distilled the buildings and surrounding landscape to their simplest forms while retaining the character of the structures and their surroundings. Even with little detail, the scene feels complete because of the artist's expert handling of the shapes.

TIN ROOF VISTA | Carolyn Lord | Watercolor
11" × 15" (28cm × 38cm)

Using Shapes to Define Content
The buildings and people are not very detailed, but the accuracy of the shapes and perspective creates a very realistic feel. The human forms in the shadow at the lower right are simplified and almost form one shape, but they significantly add to the feeling of activity in this busy street scene.

PLAKA | Jean Grastorf | Watercolor | 20" × 28" (51cm x 71cm)

"When the subject is strong, simplicity is the only way to treat it."

—JACOB LAWRENCE

how to use the visual elements, such as changes in value—an element that will be discussed later in this chapter—to create the illusion of depth.

Shapes can be figuratively accurate or modified. For example, distortion may be used to add to the emphasis of a shape. Paul Cézanne, Vincent van Gogh and Amedeo Modigliani, among others, often created abstract shapes that were very distorted. But what expressive content they created with those unique shapes!

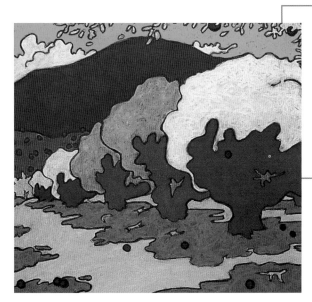

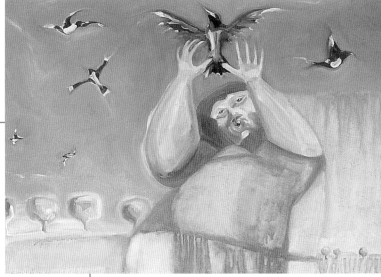

Communicating Feeling With Line and Shape
Gasparich loves the landscapes of the American southwest and uses simplified shapes to make strong visual statements in his paintings. His shapes are boldly and lovingly created. Look at the intricate edges of the natural contours. Do you find these shapes appealing?

FALL ORCHARD | Vince Gasparich | Oil pastel
18" × 22" (46cm × 56cm)

Using Distortion to Convey Meaning
McGivern frequently uses distorted shapes in her paintings. Here, the distortion of the woman's body grounds her, creating a contrast with the birds taking flight. How do the shapes of the birds depict movement? Could a realistic rendition have conveyed the pure abandon of the first moment of flight as energetically as this one?

FLEDGLINGS RELEASED | Peggy McGivern | Oil
16" × 23" (41cm × 58cm)

CONVEYING COMPLEX MESSAGES THROUGH COLOR

Color is the most complex of the elements; it has an infinite number of variations. It can be dark or light in value, intense or subdued in saturation, and warm or cool in temperature. Humans respond on emotional levels to color based on universal, personal and cultural meaning. Color conveys myriad messages and moods. When we're sad, we're blue. We turn green with envy. Red arouses passion.

Each of us also has personal associations with or preferences for colors. Artists choose colors for symbolic or psychological reasons, or simply because they are appealing. Known for his vibrant use of color, van Gogh had this to say: "...instead of trying to reproduce exactly what I have before my eyes, I use color more arbitrarily so as to express myself forcibly." One need only to look at one of his paintings to know the truth of his words.

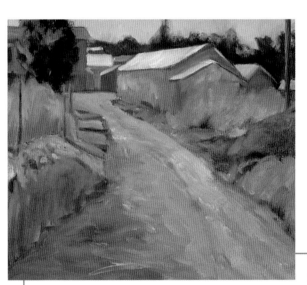

Complementary Colors
Toms has chosen a *complementary* color scheme that has a consistently warm feel but also contains cool colors. Complements appear directly across from one another on the color wheel. Notice how the contrast of the cool blues and greens intensifies the warmth of the reds and oranges. Imagine how the painting would look if warm or cool colors were used exclusively.

VILLAGE AT SUNSET—LOCKE | Leslie Toms | Oil
12" × 12" (30cm × 30cm)

Analogous Colors
Burridge creates harmony along with intensity by using a color scheme of red, orange and yellow. These are *analogous* colors, which means they are in close proximity on the color wheel. Do you feel you might want to use analogous color schemes to make statements about mood and harmony in your work?

FIESTA DEL SOL | Robert Burridge | Acrylic
30" × 80" diptych (76cm × 203cm)

Once I copied one of Vasili Kandinsky's images to try to understand his approach to color. When I painted an arm purple, as he did in his painting, I giggled in delight. It felt as if he had given me permission to do something I never would have dared to do on my own. This experience helped me to understand more about my personal preferences. I learned that I don't care about accurately depicting color and shapes as much as I care about freely expressing my responses to my subjects.

Color choices, then, are highly personal. There are no right or wrong colors. You may enjoy trying to capture the light just the way it falls on a favorite tree, striving to use the "real" colors of nature. Or you may have your own reasons for painting the tree in shades of pink and orange. Gauguin had his colors "wrong," but what dreamlike and alluring paintings he made as a result.

"All colors are the friends of their neighbors and the lovers of their opposites."

—MARC CHAGALL

Using Contrasting Colors

This image contrasts bright, warm colors with dark, cool accents. I sense joy and delight in the painting. What impression do you get from McKasson's use of color? Do you find the contrasts appealing?

GARDEN COLOR | Joan McKasson
Watercolor and gouache | 22" × 30" (56cm × 76cm)

Creating Depth With Color

Casey loves to capture the beauty of nature using the full spectrum of colors. She also uses color to create movement and depth in this painting. What colors come forward? Which ones recede into the distance? Does using color to create depth and perspective interest you?

GLORY | Bonnie Casey | Oil | 20" × 24" (51cm × 61cm)

73

Vince Gasparich

"If what you're doing looks right and feels right, you're probably on the right track."

PHOTO BY KIM JEW

VINCE GASPARICH lives in Albuquerque, New Mexico, with his wife and two young children. He combines his art-making, in a studio he built in his garage, with a full-time job in promotions at a television station. He depends upon the elements of line, shape and color to achieve simplification and bold impact with his art.

How do the elements serve you in expressing your visual voice?
In New Mexico the landscapes are big and bold so I use line, shape and color to help express this. These elements are important to me because I like to simplify the images as much as I can, giving as little detail as possible. The outlining of shapes makes the work stronger and bolder to me—it just seems natural. I've tried not outlining, but the work doesn't feel finished without it.

Your line isn't just a flat outline; it's more sensitive than that.
Thanks. I try. It's not the last thing I do. I work the line in at the same time as I'm layering. I also vary the line from thin to thick for greater expressiveness.

A Personalized Approach
Gasparich's strong lines delineate the abstracted forms of the land and vegetation and add character to his landscape paintings. Even with simplified forms, he creates a sense of depth in his landscapes by using overlapping shapes and lines to suggest perspective. I feel like reaching out and touching the pumpkin in the foreground. What is your reaction to the shapes and forms?

MESILLA VALLEY | Vince Gasparich | Oil pastel
12" × 16" (30cm × 41cm)

Creating Perspective With Line and Shape

Here Gasparich uses lines and shapes to give the viewer a sense of moving back in space. Notice how lines define the field furrows and then recede into the background. His shapes diminish in size to further enhance perspective. Imagine this image without lines and see how much flatter it would appear.

CORRALES HARVEST | Vince Gasparich
Oil pastel | 18" × 22" (46cm × 56cm)

How would you describe your marks?

Sort of circly, scribbly kind of movements. I like to play with the pastels. I'll use harder pastels first and then use softer ones on top. Actually, I started with pastels because I was living in an apartment in Dallas and they were easy to put away. Then as I worked with them I discovered I loved the richness of the colors.

How do you get ideas for your paintings?

I get inspiration from all different things. I worked as a news photographer for a long time and was surrounded by an often ugly reality. Now I've gone back to nature. Maybe it's a response to dealing with crime, death, that sort of thing. I look for icons of New Mexico: thunderheads, poplars, and things to go with them.

What is your painting process?

I'm not very good about completely planning out paintings before I start. I'm in awe of watercolorists who seem to know exactly how the painting will look before they even begin. I'll work on a drawing until I like it compositionally and then begin to build up layers of color. I may go through three or four different color choices before I'm satisfied with the overall look.

How do your personality and your approach to painting reflect each other?

Maybe I get to be really sort of an extrovert doing these big, bold paintings. I'm not that kind of person—not really shy, but not a "look at me" kind of person. By painting this way, I get to be more extroverted through my work. You would definitely notice one of my paintings on the wall.

What advice would you give readers about their search for which art elements to emphasize?

If what you're doing looks right and feels right, you're probably on the right track. It's good to look at other people's work, but you have to make it your own. Try lots of things to see what works for you. Oftentimes, I question my art because it's whimsical and happy. I feel good about my paintings but sometimes wonder if they are serious enough. I think a lot of artists are doubtful and question what they're doing, but I think being doubtful of yourself sometimes might push you to really think about your work.

Catching a Fleeting Outdoor Moment

Susan Sarback | Sarback is a plein air painter whose passion is capturing light and color at various times of the day and in different seasons. She has developed a painting technique of blocking in the major shapes in a scene, then assigning a warm (sunlit) or cool (shadow) color to each shape.

This plein air painting was completed in an hour and a half. Sarback had to paint rapidly to capture the quality of light before it changed. This demonstration shows how light and color can define forms and imply depth at a specific time of day.

MATERIALS

Surface
11" x 14" (28cm x 36cm) gessoed Masonite panel

Oil Paints
Cadmium Lemon • Cadmium Red • Cadmium Yellow • Cerulean Blue • Cobalt Blue • Dioxazine Purple • Indian Yellow • Permanent Magenta • Permanent Rose • Titanium White • Ultramarine Blue • Viridian Green • Yellow Ochre Pale

Other
Vine charcoal • 2 ½-inch (64mm) flexible stainless-steel palette knife, with a dip in the handle (Holbein SX series)

Reference Photo
This photo was taken at 9:15 A.M. on a sunny, late spring morning in Fair Oaks, California. The background cliff with trees was in full shadow, and the water, sand and a few trees were in sunlight.

1 Simplify the Scene to Its Main Masses
Using vine charcoal, I simplify the composition into five major masses as determined by the areas in light and the areas in shadow.

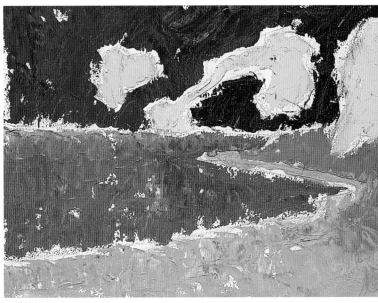

2 Create the Underpainting
In the underpainting stage, I define the light source by establishing relative values and temperature. The shadows are painted with various cool colors—blue, violet and green—and the light planes are painted with warm colors—yellow, orange, red and pink. I start with simple, overcolored bold shapes.

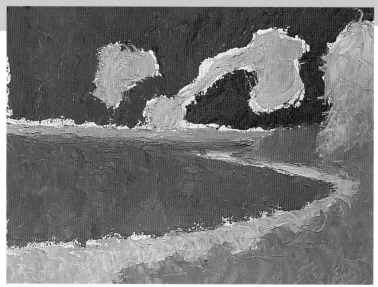 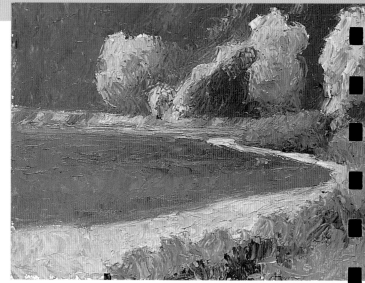

3 Establish Color Relationships

I refine the colors of the major masses to establish correct color relationships. I see and paint the masses as they differ from each other in value (light/dark), temperature (warm/cool), and chroma (bright/dull). You can see how I changed the water from the original orange in the underpainting to a greenish color. The warmth of the orange under the green maintains the sunlit effect.

4 Develop Depth and Volume

I develop a three-dimensional appearance by creating color variations within each mass. Notice how the water now has four distinct variations of color. These are different in temperature yet similar in value. This helps to show recession on a flat plane. The trees also have bands or variations of color that help create volume.

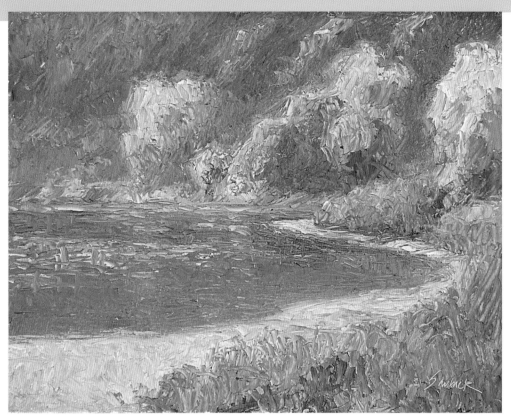

5 Add More Color and Edge Variation

Finally, I develop more variations of color and vary the edges. I suggest form in the background trees and do more color development in the foreground grasses and the water. Notice that the highlights in the water are painted in this last stage even though they were initially obvious. All the edges are varied, and the sharpest edges with the highest contrast are located at or near the focal point: the back curve of the shoreline and nearby trees.

AMERICAN RIVER MORNING | Susan Sarback | Oil | 11" × 14" (28cm × 36cm)

STAGING A SCENE WITH VALUE

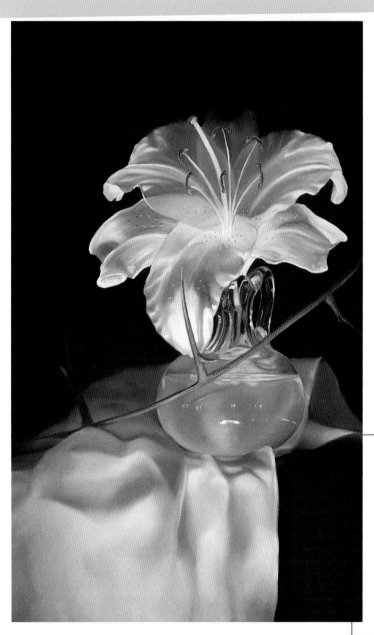

Value refers to how light or dark something is. We see values most clearly when looking at a painting or photograph in black and white with shades of gray. But all colors have a value, too, ranging from very light to very dark.

Artists need to develop the skill to see value along with color, as we saw in Susan Sarback's demonstration of her technique. Painters who emphasize value over color are called *tonalists*, while those who emphasize color are referred to as *colorists*. All artists combine or move back and forth between those approaches, as Sarback does, depending on what they are trying to communicate. However, some painters do have a definite preference.

In a painting in which you choose to emphasize value, you need a good underlying value pattern to give the work visual strength and cohesiveness. This is achieved by organizing the shapes of similar values into large groups or by connecting those shapes in some way.

Achieving Beauty With High Contrast

Nicora Gangi has reduced her image, inspired by a biblical passage, Revelation 1:8, almost to a black-and-white value painting. The high contrast emphasizes the beauty and fragility of the lily, a symbol of Mary's purity, and the cleansing qualities of water, shown in the cruet. The colors are complementary, and most of the hue contrasts are orange and blue to give the work a subtle but dynamic unity.

LILY AND THE LAMB | Nicora Gangi | Pastel
19" × 14" (48cm × 36cm)

"If I could have had my own way, I would have confined myself to black and white."

—EDGAR DEGAS

To test the strength of a value composition, view the image from a distance or squint at it to eliminate the detail so you see only the overall shapes that make up the underlying masses of light and shade. Do the dark and light areas flow together in a unified pattern, or do they break into individual spots? Disconnected values can destroy the integrity of a painting. You also want to avoid an exact fifty-fifty light-dark split because an image is much more interesting if either dark or light values dominate.

Your paintings should retain visual strength when viewed from *any* distance. I learned this lesson when I once painted a particular image containing large, bold, simplified shapes that would be visually powerful from across a room. I showed my painting to a friend who is an art professor. She told me the painting was successful when viewed from a distance, but was disappointing and uninteresting when examined up close. I experienced an "aha moment" as I realized that large, bold, abstract shapes alone don't make a good painting. I had not considered using subtle variations, such as with color or texture, to give the surface richness for the nearby viewer to enjoy.

Balancing Contrasting Values
McKasson has created a striking value painting. Squint your eyes and you will see that while the light values predominate, an intensity is created by the darks. The lights are beautifully woven from the foreground into the light of the flowers and finally into the moon. The moon is a slightly darker value so as not to compete with the flowers or contrast too strongly with the dark background.

BY THE LIGHT OF THE SILVERY MOON
Joan McKasson | Watercolor | 22" × 30" (56cm × 76cm)

Low-Key Values

In a low-key value painting, darks predominate. Casey gives the image more impact by contrasting strong lights and darks rather than transitioning from one to the other with middle tones. I can feel the grime and hear the steely noise of this industrialized area. What impressions do you get when you look at the image?

CHICAGO | Bonnie Casey | Oil | 11" × 14" (28cm × 36cm)

High-Key Values

Lighter values predominate in a high-key painting. The extremely high contrast in value and the crisp edges of the petals heighten the effect of sunlight on these flowers. This painting demonstrates how careful planning and artistic choices can enhance the visual power of the image.

TWIN BEAUTIES | Brian Davis | Oil
24" × 36" (61cm × 91cm)

Organizing Value to Create Visual Strength

Acosta creates a strong dark-against-light value pattern in this piece. To unify the image and avoid a cut-out look, she connects the lights and darks in several ways. The eagle and flame-like area blend together; dark lines and patterns within the light areas tie them to the darker mass; a broken horizontal line across the flame-like area connects it to the lighter background on the right. These value connections also add energy and interest to the overall image.

EAGLE NO. 4 | Cristina Acosta
Oil and metal leaf
48" × 96" (122cm × 244cm)

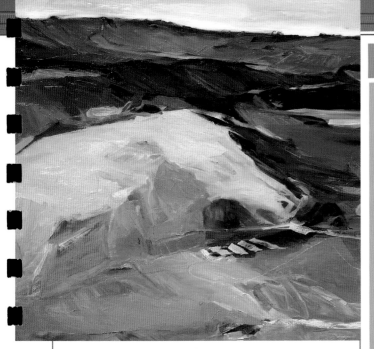

The Relationship of Color and Value

Until only about a hundred years ago, producing paints was a labor-intensive process; in addition, the number of available pigments was limited. Advances in technology during the last century made a wide range of colors available in easily transportable tubes. A revolution in color, style and approach followed as painters left their studios to work outdoors in order to capture the colors, light and aura of nature. Some artists became quite passionate about color. Monet voiced his passion when he said, "Color is my day-long obsession, joy and torment."

Value, while still an important consideration, is sometimes secondary to artists who are primarily colorists. But, as with most aspects of art, there is a continuum and many artists find themselves somewhere toward the center. If you fall within that middle range in your use of color and value, try incorporating strong value and color elements by using colors of the same value and saturation (intensity) in your larger shapes. This approach will help hold an overall abstract design together.

Combining Color and Value
This example combines intense interesting color and a strong value pattern. Squint at the image to see how the light and dark values are organized into larger shapes. Notice the variety of colors used within these shapes to enhance visual interest and lead the eye to explore the image more thoroughly.

SPRING HILLS | Barbara Rainforth | Oil
48" × 48" (122cm × 122cm)

Value Only
The same image has been reproduced with all color removed to demonstrate how Rainforth has organized her value pattern. Notice how the image still holds up when you only see black, gray and white. The artist has not only mastered color, but has also created a strong underlying value pattern.

83

Guiding the Eye With Value Contrast

Cynthia Britain | Well known for her plein air painting, Britain decided several years ago to explore other subjects and began painting the human form and doing portraiture. In this demo, she uses contrasting values to bring attention to the face and body of her model.

MATERIALS

Surface
11" x 14" (28cm x 36cm) linen glued to board

Brushes
Natural bristle flats and synthetic sable filberts, sizes no. 2 to no. 10 • rigger

Oil Paints
Alizarin Crimson • Burnt Sienna • Cadmium Orange • Cadmium Red Medium • Cadmium Yellow Medium • Cerulean Blue • Ivory Black • Magenta • Sap Green • Titanium White • Ultramarine Blue • Viridian Green • Yellow Ochre

Other
Soft rag or paper towel

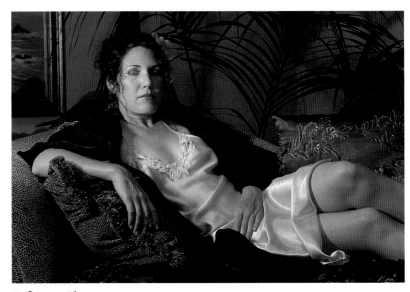

Reference Photo
For my model, I want a relaxed, reclining figure with a lyrical pose and asymmetrical design. The negative shapes of the background contribute to a strong abstract composition. The balance of complementary colors is purposeful as well, creating an effective color harmony and a contrast in temperatures (cool background against warm skin tones).

I want the strongest light to fall on the right side of the model's face and her shoulders—the focal point—to create drama. The light in the rest of the room, including that on my canvas and palette, must be lower to provide value contrast on the model.

1 Tone the Canvas

I mix a cool, midvalue gray using Titanium White, Ultramarine Blue and a little Burnt Sienna. Then I add some Yellow Ochre and a bit of Burnt Sienna to this cool gray to create a warm gray to tone my canvas. This warm background allows me to see other colors and values accurately and also to "wipe out" areas where I want light values. I tone the canvas using a soft rag or paper towel, keeping the layer thin and even.

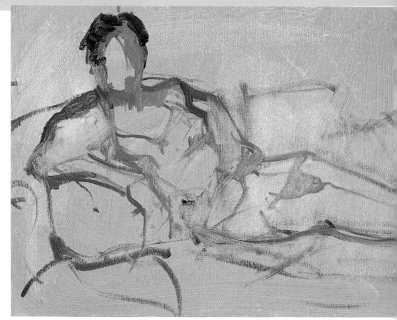

2 Sketch the Figure

I begin the initial sketch in paint using a no. 2 flat or filbert. I like the fluidity of drawing with paint and the way it easily enables changes. Observation is important in this step because I need to measure and compare proportions and respect the rules of anatomy.

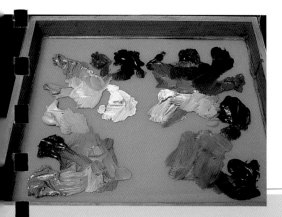

Palette Setup

I set up my palette to achieve an economy of effort in mixing colors and values. My colors are laid out clockwise, beginning with the earth tones, Yellow Ochre and Burnt Sienna; then Cadmium Yellow Medium, Cadmium Orange, Cadmium Red Medium, Alizarin Crimson, Magenta and Ultramarine Blue. On the right margin I place Cerulean Blue, Viridian Green and Sap Green. This gives me a cool tone and a warm tone for each color.

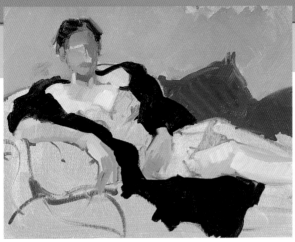

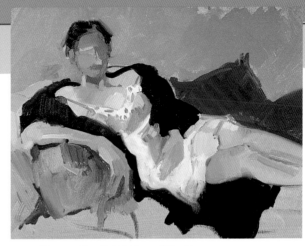

Block In the Puzzle Pieces

3 Next, I look for the big shapes and masses. I see the figure and the setup as a big puzzle. The challenge is to block in just the pieces and strive for accurate color and value.

Convey the Subtleties of the Form

4 As I continue to lay in the shapes and values, I analyze the subtleties of the figure's form. She needs to feel three-dimensional and have visual weight. The values of her skin tone and dress are relatively light, but the shadows on each are crucial to revealing her form and the direction of light.

Refine the Body and the Face

5 Now that I am satisfied with the overall design and composition of the work, I focus on refining the anatomy and the facial features. I spend more time on the face than any other part of the painting, while still handling it in the same style.

At this stage, I begin to apply more paint and use more direct brushwork, making each stroke really count. The strong directional light on the model's face and shoulder area becomes important in creating drama. The rest of the model's body is subordinate to her face but creates a strong linear design to provide movement in the picture.

6 Add Reflected Light and Color, Then Evaluate the Edges

Facial detail that might be important to a realistic portrait painter is not what I want to depict. I am much more intrigued with the reflected light and color in both the shadow and light areas. I want to capture the mood and the message as if they were visual music. For instance, I add a hint of Cerulean Blue at the top edge and have it reflect off the model's shoulder and forehead. Adding this cool highlight actually creates a warmer overall feel.

The final step always means evaluating edges. It is very important to the overall flow to purposefully decide where I want soft edges versus hard edges. In this particular work, I wanted most of the edges to read as soft to integrate the figure into the setting. I left a few edges harder, such as her shoulders and neck, to bring focus to her face and shoulder area.

I was able to achieve color harmony by adding intensity to the magentas and golds to the green background to create an overall warm effect. I titled the painting *Saturday Night*. The viewer's imagination can finish the story!

SATURDAY NIGHT | Cynthia Britain | Oil | 11" × 14" (28cm × 36cm)

TANTALIZING THE EYE WITH TEXTURE

Texture refers to the surface quality of a painting. Texture can be either *actual* (tactile) or *implied* (visual). You can feel actual texture if you move your fingers over the surface. Vincent van Gogh applied undiluted paint in thick swirling patterns. The resulting ridges and raised edges of the paint strokes are obvious to the viewer's eye. This technique is called *impasto*, the thick irregular buildup of paint that creates a rough surface. Some artists even attach items to their images, using techniques known as *collage* (adhering flat items to the painting surface) and *assemblage* (adhering three-dimensional items to the painting surface).

Implied or visual texture gives only the impression of texture. Matisse created wonderful implied textures with his fabric and wall designs by arranging lines, shapes, colors and values into textural illusions. The Old Masters took this to a high

Impasto for Surface Texture

Cheri Christensen uses impasto to create actual surface texture. Thick, spontaneous strokes create the feeling of the swirling, soft hair of the cat. The unblended brushstrokes further contribute to the feeling of softness.

TINK ON THE EDGE | Cheri Christensen | Oil
12" × 9" (30cm × 23cm)

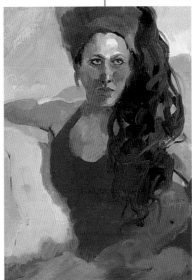

Combining Actual and Implied Texture

Britain uses impasto brushstrokes along with the implied texture of value and shape to create the textural richness of the figure, costume, hair and background. Does creating the illusion of texture interest you, or do you prefer actual texture? What techniques have you used to communicate the texture and feel of something?

QUEEN OF SHEBA | Cynthia Britain | Oil
12" × 9" (30cm × 23cm)

form when they painted detailed renditions of the fabrics and jewels worn by the wealthy subjects of their portraits. *Trompe l'oeil* painting, creating the illusion of photographic realism, is the ultimate in implied texture.

In both tactile and visual texture, it is our sense of touch that is engaged. You might feel the urge to reach out and touch paintings that emphasize texture. (This is, of course, strongly frowned upon at museums and galleries!)

Another means of implying texture is through the use of pattern, which means the repetition of an element, usually a shape. Pattern may be non-representational; that is, not meant to represent actual texture, but intended to add visual interest and appeal to the surface.

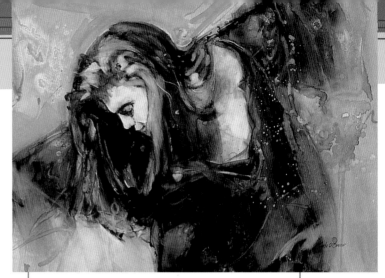

Making Texture With the Medium

O'Connor employs the flowing qualities of *gouache* (opaque watercolor) to create a soft textured look. The loose, delicate and sensitive handling of the medium adds to the feel of this painting and enhances the beauty of the model. Notice the effective use of value along with unusual shapes that are the result of the interesting pose.

BLACK GOWN | Carla O'Connor | Gouache
22" × 30" (56cm × 76cm)

Creating Texture With Collage and Assemblage

McLain glazed the surface with several transparent layers of acrylic, then applied torn bits of red Japanese paper over it to achieve the red patterning. The blue Nile is a string of glass beads, and the black shapes are torn pieces of Japanese paper. The paper and beads were attached to the surface with acrylic medium. Does working with a variety of materials to achieve texture interest you?

KEMET/DESHRET NO. 6 | Helaine McLain
Acrylic and mixed media | 12" × 12" (30cm × 30cm)

"I decided that since I can't paint every single hair, I would use pattern to make the animals more interesting ... I have to use color, value and texture to get the effects I'm after."

PHOTO BY MICHAEL BUSH

ANNE EMBREE creates unique paintings about personal discovery and opportunities for development. Her work, much of which incorporates animals, is noted for her exquisite handling of color, value and texture.

Where did you get the idea to do collage and assemblage?
A few years ago I started doing more modeling with the images of animals. I felt I had simplified them too much and I tried using texture to capture the animals' souls. The technique I used was to build up and scrape off my paint until I had the desired effect. I've started using paper and found objects to incorporate and attach to my images. For example, last fall a friend was moving and throwing out her daughter's childhood drawings. I took them, created collages and then painted animals on top. In my latest work, I'm attaching objects, such as

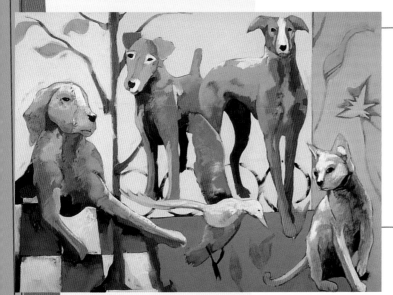

Creating Texture With Patterns and Shapes
Embree uses patterns and shapes to create texture and rhythm, as in the black-and-white pattern in the lower left of the image and the four circles behind the legs of the two standing dogs. These patterns and shapes, along with the leaf patterns on the tree and wall, create a design that adds richness and interest to the painting.

ON THE OUTSIDE LOOKING IN | Anne Embree | Oil
38" × 50" (97cm × 127cm)

Creating a Visual Story Using Assemblage

Embree chose to paint a mouse because she saw so many in Santa Fe during the summer that she started this series of paintings. She found the country club sign as she walked her dog one day and put the two items together to express a dilemma: the mouse looks cute on the chair, unraveling an actual piece of raffia, but this is a country club—no place for a mouse! The letters were cut from a *New York Times* article on ecology, adding meaning to the statement.

MUST WE KILL THE MOUSE? | Anne Embree | Mixed media
41" × 37" (104cm × 94cm)

metal gears and license plates, that I find along the railroad tracks when I take my dog for walks. I recently switched to acrylics and I use it to build layers to add pattern to the surface. And I incorporate little color chips, the ones you find at the paint store.

Many of your animals have unusual patterns, such as checkerboards, on their bodies.

I decided that since I can't paint every single hair, I would use pattern to make the animals more interesting. I don't see well out of my left eye, so my vision lacks depth perception and I'm pretty much a flat painter. I have to use color, value and texture to get the effects I'm after.

How do you choose which animals to paint?

A lot of it is unconscious. I love animals, so they were a good subject for me. I use them to give myself a composition; they are a design element. In my paintings, the animals are important as subjects, but so is the negative space. I may decide to add a bird or a duck in the middle of a group of dogs because it's the right size and shape for the composition. My choices are not usually based on content, but on the needs of the composition.

Your paintings are so original. How do you go about creating them?

My first concern is composition. So the shapes are really first. I have to work at color because my brain just doesn't get to it right away. I almost never finish a painting with the colors I have in mind at the beginning! I draw the animals and then enlarge the drawings and cut them out to make stencils. I lay the stencils down and move them around to plan my composition. Sometimes I start by creating an interesting background and then lay the animals on top. In your paintings you balance color and value so that neither is secondary to the other.

How do you achieve this?

I do it almost unconsciously now. It came with learning color harmony. When I first started painting, I had a wonderful mentor in Denver named Kang Cho. He gave me Peter Paul Rubens's palette, which contains a limited number of colors, and taught me how to paint. I learned over time to mix colors and get values. Cho really emphasized harmonizing color, something the Old Masters did. It takes time to learn because you have to see the subtleness and know how to achieve the same value in the colors. In my work, I mute the colors. The areas that are less muted and brighter are my focal points.

91

REVIEW AND REFLECT

QUESTIONS

1. Which element(s) did the artist choose to emphasize in each image? What was achieved with the element(s)? (Answers on page 94.)

2. Compare and contrast how artists can use the same elements but achieve very different results.

3. Do you find yourself repeatedly responding to some elements more than others?

4. Review the images once again, this time more slowly. For each one, observe the subtleties and note the details that strengthen and enliven the work. What effects are achieved by the use of elements in addition to those mentioned in the answers on page 94?

5. Do you see one or more elements used in ways you might like to try in your paintings? What effects would you like to achieve with the selected elements?

✅ WHAT SPEAKS TO YOU?

Check the boxes next to the paintings that appeal to you most.

- What is it about these paintings that appeals to you?

- What is it about the unmarked paintings that is less appealing to you?

A ☐

B ☐

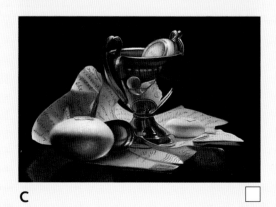

C ☐

D ☐

G ☐

H ☐

E ☐

I ☐

F ☐

ANSWERS TO QUESTION 1

A *Pears*, Liz Kenyon, pastel, 10" × 15" (25cm × 38cm). **Shape and color:** It is the accuracy of the pear shapes, shadows and shelf that give the work a realistic feel. This proves an important point about color: if the shape is accurate, objects that are painted unnatural—even wild—colors can still be interpreted as realistic.

B *Saturation*, Barbara Rainforth, oil, 40" × 53" (102cm × 135cm). **Line and color:** Here the line plays a crucial role by indicating direction, creating texture and defining edges. Rainforth adds intensity to the color by choosing a dark value for the juxtaposing line.

C *Letter to Pergamum*, Nicora Gangi, pastel, 12" × 15" (30cm × 38cm). **Value and implied texture:** Gangi uses value to create a dramatic still life while defining the full volume of the objects. There is also an implied texture created with the writing on the papers and the reflections on the bowl and spoon, which clearly define them as metal.

D *Spring Violets*, Linda Kemp, watercolor, 11" × 11" (28cm × 28cm). **Shape:** Kemp creates shapes, her primary interest, by painting the negative space that surrounds them. The intricacies of the overlapping vine shapes produce a textured effect.

E *Dos Rosas (Two Roses)*, Cristina Acosta, oil, 48" × 48" (122cm × 122cm). **Texture and line:** Acosta starts with a textured surface and uses line to define the shapes of roses, stems and leaves. By choosing a dark value for the line, the forms hold their own against the highly textured background.

F *The Lesson*, Cheri Christensen, oil, 18" × 36" (46cm × 91cm). **Actual texture (impasto) and implied line:** Christensen creates actual texture on the surface by applying very thick paint. Notice how the placement of the chicks creates an implied line that leads to the mother hen.

G *Untitled*, Carla O'Connor, gouache, 30" × 22" (76cm × 56cm). **Line, texture and shape:** O'Connor uses line to draw and define the figure. She also uses line in the background to integrate the figure and ground (positive/negative spaces). Texture also is added to the figure and the background to further enhance the image. The well-drawn and accurate shapes give the figure a realistic feel.

H *Tried & True*, Anne Embree, oil, 36" × 48" (91cm × 122cm). **Texture by means of pattern:** Embree takes a beautifully drawn, realistic image of a horse in profile and adds texture to enliven the image. The wonderful flow of the dark values creates a path for the eye to follow.

I *Taste of the Sea*, Rhonda Egan, oil, 28" × 24" (71cm × 61cm). **Color:** Egan's primary interest is capturing the colors of the light and shadow as they appear at this moment in time.

THOUGHTS ON QUESTIONS 2–5

NOW IT'S YOUR TURN

EXERCISE 1
EXPLORING VALUE

Collect a few examples of paintings you like that you can photocopy in black and white. Strong value patterns will show up in black and white. Are the images as appealing to you in black and white? This exercise may give you a clue about how important value is to you. I tried this with images by Cézanne. I had thrilled at his paintings, but found the black-and-white images much less appealing because they lacked contrasts in value. This is because he employed contrasting temperatures, not values, to define forms. This helped me realize color is of greater interest to me than value.

EXERCISE 2
WHAT DO YOU EMPHASIZE?

Look at several of your own paintings.

- Which elements have you emphasized?

- What were you trying to achieve with these elements?

Now, striving to be as objective as possible, see if there are elements you can add or take away to strengthen your work.

- Which elements might enhance your visual statement?

- Have you emphasized too many elements? If the image seems confusing rather than unified and cohesive, you may want to tone down some elements.

EXERCISE 3
CHANGE OF EMPHASIS

Choose one of your own paintings and identify which element(s) you emphasized. Now, re-paint the piece choosing a different element to emphasize. When you are finished, consider the following questions:

- Did the change in elements also change what you were trying to express? In what way?

- Did this new emphasis feel natural to you?

Emphasizing different elements in a series of paintings of the same subject could be a very important experience in finding your visual language.

EXERCISE 4
EXPLORING COLOR

Most artists develop preferences, which may change over time, for particular palettes or groupings of colors. Experimenting with color expands your formal artistic skills as well as your visual vocabulary. Try, for example, working with colors you don't particularly like or have not used in the past to see what happens.

- In a workshop taught by Wolf Kahn, we learned that one of the ways he challenges himself and keeps his work fresh is to use a color that is unusual or acidic to his eye. He then tries to bring the other elements in his paintings into harmony with that uncharacteristic color and the problems it creates.

- An artist whose work appears in this book never liked using pink in her art, believing it represented negative, stereotypical female traits such as dependency and weakness. She overcame her aversion to this color by creating a series of paintings in which pink was the dominant color. The resulting images are extremely appealing and full of power.

4 DISCOVER YOUR COMPOSITION STYLE

Composition is design and organization. Its purpose is to invite viewers' eyes into your painting, encourage them to explore the various components of the work and, at the same time, keep them from leaving the painting. Supporting goals of composition are to make your paintings visually balanced and rhythmic. Regardless of the source of your inspiration and the subject and art elements you choose, composition is what pulls everything together into a unified whole, and it is an essential part of expressing your visual voice.

Not everything in nature and the "real world" lines up to create an effective composition. Many artists agree that good composition rarely happens naturally, and it is up to them to arrange the components in their paintings so that they work visually. Edgar Degas went so far as to say that "even in front of nature one must compose." John Clymer, who painted scenes of the old American West, simply placed things "where they ought to go."

An important part of composition is keeping the big picture in mind. As Ian Roberts points out in his book, *Creative Authenticity*, if you just keep moving the brushes and hope you are creating a painting that works, chances are good that it won't. You, not the brushes, have the intelligence to decide how to best compose your painting. You have to keep the big picture—the total design—in mind.

> *"Good composition is like a suspension bridge: each line adds strength and takes none away ... Get the art of controlling the observer; that is composition."*
>
> **—ROBERT HENRI**

Do you prefer a single focal point or all-over interest?

96

What is your viewpoint?

How do you organize your paintings?

Which formats work for you?

FINDING A FORMAT

Format refers to the shape and size of the painting surface. It is amazing how something so seemingly simple can affect the outcome of a painting and convey different visual messages. Choosing your format is directly related to what you want to say. It is a choice that will affect the viewer's first impression of your painting and set the tone for how the work is viewed.

The rectangle is a comfortable, common format for painting. It does present you with another decision to make: will you orient the painting vertically or horizontally? These are traditionally referred to,

Portrait Format
These are the same falls painted from a slightly different angle. Notice how simply changing to a vertical format expresses the sound and power of the crashing water, altering the whole feel of the painting and how we react to it.

BURNEY FALLS, LATE DAY | Susan Sarback | Oil
28" × 20" (71cm × 51cm)

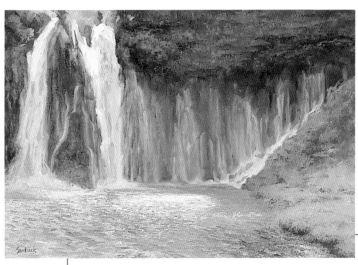

Landscape Format
The "wide-screen" format used here gives a panoramic view of the falls, emphasizing their expanse and grandeur.

FALLING FREE | Susan Sarback | Oil | 20" × 30" (51cm × 76cm)

respectively, as *portrait* and *landscape* formats.

This is probably because people—whether standing or seated—are generally vertical shapes, while landscapes usually unfold horizontally across our view. Of course, you will see many variations of the traditional formats.

A square surface is another choice. I once went through a phase when I painted on square canvases exclusively. They felt very solid to me at that time, perhaps because my life was unsettled and I needed the stability of the equal horizontal and vertical sides. This is an example of how art often reflects unconscious aspects of our lives.

The dimensions of rectangles and squares can vary dramatically, from very small to huge. You may develop a preference for certain size (or *scale*) ranges, or you might like using a variety of sizes depending on the impact you desire for a particular painting. Changing the scale affects many aspects of a painting, including composition, style and size of brushstrokes, and the amount of detail. Paintings have a definite relationship to their size and format and cannot be enlarged or reformatted without changing their original intent. When these

Choosing a Format That Fits

When you have an idea for a painting, try putting out a number of canvases and visualize the idea on each one. Ask yourself these questions:

- How would each one help me express the message and mood of the painting? Does one format better fit the composition I have in mind?

- How will the medium I am using work with various sizes? (For example, it is challenging to successfully work with watercolor on a very large surface.)

After a while, one size may just "feel" right. Choosing a format is largely an intuitive process.

are changed, as Matisse explained, "one must conceive [the painting] anew in order to preserve its expression."

Who says you have to stay with rectangles or

99

Using Format to Convey Meaning
This very tall image creates a good sense of the height over which the puma is jumping. Acosta wants to convey the idea of taking risks and making changes in our lives.

PUMA | Cristina Acosta | Oil | 60" × 36" (152cm × 91cm)

Different But Related Subjects
This painting holds together because of the closely related subject matter within the individual squares. Sometimes artists, including Burridge, choose to paint the same subject over and over, within each of the smaller divisions. Variety and interest are achieved by painting each image a little differently.

MARKET DAY | Robert Burridge | Acrylic | 22" × 15" (56cm × 38cm)

squares? Surfaces with other shapes provide more options. Two artists who are noted for having worked with shaped canvases are Frank Stella and Elizabeth Murray. In the 1960s, Stella did a famous series of paintings on a variety of shaped canvases, many of which had curved edges. Murray, a well-known New York City painter, has her canvases custom-built in the shapes of her subjects.

In addition to using various shaped surfaces, you can divide your surface into zones, such as squares, and then paint within these areas. You can even combine two canvases (*diptych*) or three canvases (*triptych*) together. These formats challenge you to present images that relate to one another in such a way that they create a statement greater than a solitary image would.

EXPLORING THROUGH A SERIES

Some artists enjoy creating a series of paintings. A series may be related by subject matter or a message the artist wishes to convey. An important characteristic of a series is that the paintings should comprise a body of work of equal quality. It is not a progression of continually improving work to achieve a final "good" piece. That is a learning progression. As contributing artist Carla O'Connor explains, it might take you ten attempts to paint one subject in a way that satisfies you. Now you are ready to start a series based on that last painting.

A Theme-Based Series
McLain combines her fascination with the ancient Egyptian civilization with the concept of duality (opposites). To give visual voice to duality, she chose the contrasting borders of the Nile: the fertile black land (Kemet) and the barren, red desert (Deshret). The materials in this piece include turquoise beads, black metallic acrylic and acrylic ink, and layers of glaze.

KEMET/DESHRET NO. 1 | Helaine McLain
Acrylic and mixed media | 36" × 24" (91cm × 61cm)

Same Subject, Different Materials
Notice the different approach McLain uses here to represent the same subject matter: the Nile and its borders. She uses red gesso, transparent acrylic, gold Dutch metal and torn Japanese paper to create her image. Delicate gold thread is wound around the canvas and secured with acrylic gloss medium. (Other paintings in this series of ten appear on pages 61, 89 and 127.)

KEMET/DESHRET NO. 5 | Helaine McLain
Acrylic and mixed media | 12" × 12" (30cm × 30cm)

An Animal-Based Series
This image is from Anne Embree's "Groups of Animals" series. Embree loves animals and uses them as the design elements in her paintings. This series is tied together by the subject and the way the backgrounds are divided into geometric shapes.

THE ZEBRA | Anne Embree | Oil | 38" × 50" (97cm × 127cm)

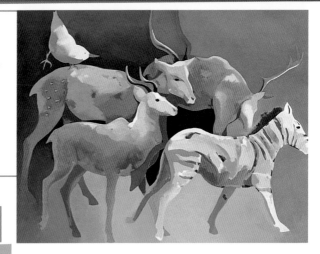

What Working in a Series Can Do for You

- Basing a series on the same subject provides opportunities to fully explore that subject. For example, Monet painted the same outdoor subject over and over to capture the effects of the changing light.

- Working on a theme enables you to present different facets of the topic.

- A series allows you to capture many aspects of your subject without overwhelming any one painting with too many elements. Instead, you can emphasize different art and design elements in each piece or try various approaches to the composition.

- Related paintings also present opportunities to work on solving artistic problems in different ways.

- For some artists, focusing on one subject enables them to expand their creativity and explore various materials and methods.

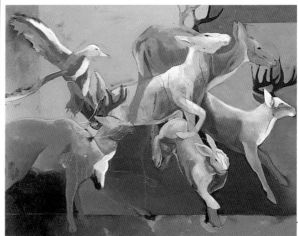

Similar, But Different
In the previous painting, the animals are quiet, but movement is anticipated. Here, the animals are clearly in motion, and Embree has chosen a different palette. What else does Embree do that unifies the two paintings and identifies them as a series? (*Watering Hole*, on page 115, is also in this series.)

FUSION OF DEER | Anne Embree | Oil
40" × 52" (102cm × 132cm)

ESTABLISHING A CENTER OF INTEREST

Most good compositions include a *center of interest*, or *focal point*. Sometimes the center of interest is dictated by the subject. If there is a human or animal in the painting, for example, the viewer's eye will naturally be drawn to this feature. (This is true unless the figure is extremely subdued or almost hidden within the composition.) Aside from the subject matter itself, there are two main methods for defining your center of interest.

One method involves contrast. A higher level of contrast at the center of interest than in the rest of the painting will create a stronger pull on the viewer's eye. To establish the focal point by this method, you can:

- use greater value contrast there

- use more detail there

- use more intense (saturated) colors there

The other method involves creating a visual path to lead the eye to the focal point. To create this path, you might:

- imply lines with repeated values

- imply lines with repeated or "pointing" shapes

- use actual lines to direct the eye

Once you have determined what you want your center of interest to be, plan everything else in the painting to lead the eye to it. Organize the composition so that nothing competes with it.

Focusing With Value Contrast
Although the birds are clearly the center of interest, Lian Zhen fills the painting with details that could compete for our attention. It is his careful control of value that keeps our attention returning to the birds. Squint as you view the image and you'll see how the birds "pop out" of the tangled branches. Zhen intensifies this value contrast by placing the birds' heads against the darkest area of the painting.

RITUAL | Lian Zhen | Watercolor | 14" × 21" (36cm × 53cm)

Focusing With Detail

Jen Bradley gives us only the slightest glimpse of detail in this still life, yet that is exactly what designates her center of interest in the bottom third of the canvas. The top two-thirds contains loosely applied shapes of various colors and values, but each contributes to bringing us back to the center of interest. Notice how the eye is led downward by the dark brush-stroke and the shape of the lighter strokes. The orange shape along the left side keeps the eye within the painting.

BROWN PEAR | Jen Bradley | Oil
24" × 18" (61cm × 46cm)

Redirecting Attention to the Focal Point

In many paintings of the human figure, the face is the center of interest. Katchen has really created an artistic challenge for herself by filling most of the surface with a highly saturated yellow. Although this could have stolen the spotlight and become the center of interest, she added a few details to refocus our attention on the face: a few spots of very light value around the face (teeth and earring) and bright red lipstick.

TELL IT LIKE IT IS | Carole Katchen
Pastel | 25" × 19" (64cm × 48cm)

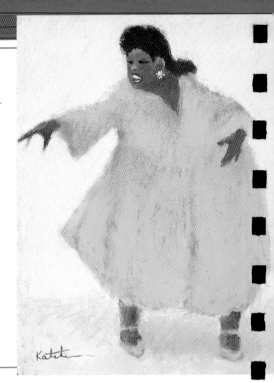

Focusing With Color Saturation

Contrast in color intensity is an exciting and powerful tool of emphasis. Przewodek uses an intense yellow—the most saturated color in the painting—to designate a clear center of interest. The rest of the image, done in more muted hues, allows the yellow truck to dominate the composition. Notice, too, how the path and lines in the structures and hay bales lead our eyes to the truck. Przewodek has then framed it with solid forms to keep our attention focused.

THE YELLOW TRUCK
Camille Przewodek | Oil
11" × 14" (28cm × 36cm)

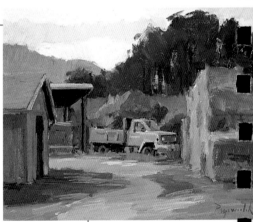

Emphasizing the Center of Interest

There is a lot of competition for the center of interest in this painting: the implied texture in the folds that show the bulk of this dog, and the brightly colored, patterned surface the dog is lying on. But notice how Connally places the red shape beside the right side of the dog's head, an addition that helps to emphasize the dog's head as the center of interest.

PRINCESS | Connie Connally | Oil | 18" × 24" (46cm × 61cm)

Creating a Visual Path

A mass of white shapes creates a center of interest. The four white flowers grab our attention and direct us to the slightly separated white flower on the left edge. The upwardly pointing petal on this flower directs us to the top of the painting. The darker diagonal shapes move us from the top to the bottom edge, then back to the main mass of white flowers. The implied diagonal lines in the flower arrangement create an overall sense of movement and animation.

COOL GARDEN MATILIJAS | Joan McKasson | Watercolor
20" × 26" (51cm × 66cm)

Guiding the Eye With Subtle Lines and Shapes

Goldsmith creates an explosive sunburst of red as the center of interest and then uses radiating lines of various colors and configurations to lead our eyes back to the red. The lightly colored shapes—the blue in the lower right and the yellow in the upper left—also form implied lines that lead to the center of interest.

ALTERNATIVES | Lawrence Goldsmith | Watercolor
18" × 24" (46cm × 61cm)

ALL-OVER COMPOSITION

Before Impressionism, paintings were expected to have a definite and clearly defined center of interest. The Impressionists liberated artists from this restriction by abandoning the use of strong value contrast to emphasize a focal point. As a result they created the concept of *all-over composition*. Few artists have absolutely no center of interest in their paintings but, like so much in art, their degree of emphasis may vary. It's important to note that all-over composition does not mean *no* composition. You still need to plan and arrange the elements to lead the viewer's eye and keep it within the picture plane.

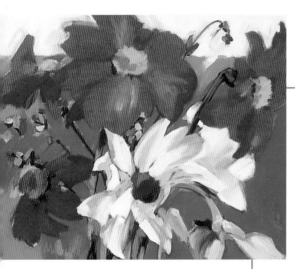

All-Over Composition Using Subject and Movement
Lemire uses two attention-drawing features throughout: high contrast with the white flower and bright color with the red ones. The curves of the flowers and stems serve as directional forces for our eyes. Starting at the bottom right corner, our eyes are led upward to explore the white flower and then on to the red flowers. The strong contrast of white and blue stops the eye from leaving the painting, and the arc of the red flowers brings us back down to the white flower.

HELLÉNIQUES (INSPIRATION FROM GREECE) | Madeleine Lemire
Oil | 24" × 30" (61cm × 76cm)

Creating Many Points of Interest
Rainforth invites the eyes to continually dance back and forth between the trees and the background. She achieves this by distorting the traditional rules of perspective. The foreground trees are painted with cool colors that we would expect to see only farther back in nature. Those trees, especially the pale yellow one closest to us, are almost transparent. Again, this indistinctness is something we would expect to see in the distance. The background colors are the most saturated, when, in nature, they would be the least distinctive.

BLUE WOOD | Barbara Rainforth | Oil
48" × 72" diptych (122cm × 183cm)

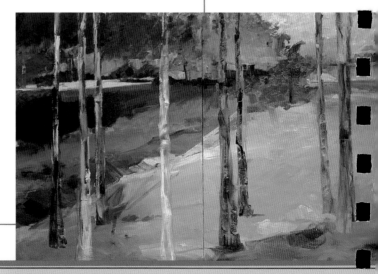

VIEWPOINT

The *viewpoint* from which you paint an image is another compositional consideration. In realistic work, all your perspective decisions are made from a *vantage point* (also called *station point*). The most common vantage point is at eye level, where you can view your subject straight on. The most effective viewpoint might be looking down from a "bird's-eye view," or you might want to look up at your subject from a "worm's-eye view." Of course, there are countless angles along the continuum of viewpoints.

Proximity to the subject is another consideration. Do you want to depict your subjects from a great distance? Some artists prefer a panoramic view of distant objects while others move in close to their subjects, creating a sense of intimacy. Georgia O'Keeffe helped us to see flowers very differently by painting them from close up in greatly enlarged detail. Sometimes she painted only a single flower—or even just a part of one—on a large scale.

Moving In Close
Britain has taken a close-up viewpoint to focus on the face of the model. She further draws our attention to the woman's expression by framing her face with dark hair that sets off her glowing skin, and by minimizing the detail in the hair and hood so as not to detract from the face.

MARY OF MAGDALA | Cynthia Britain | Oil
12" × 10" (30cm × 25cm)

Viewing From the Middle Distance

Christensen chose a vantage point far enough away to include the entire body of the animal. She also must have been sitting down, because a standing position naturally would have resulted in a downward view of the pig. Does this give us a clue about how she feels about animals? I grew up on a farm and love barnyard animals. Looking at this image, I can just imagine the artist sitting on a bale of hay as the pig grunts contentedly and enjoys the warmth of the sun.

SUNDAY'S PIG | Cheri Christensen | Oil
16" × 20" (41cm × 51cm)

Viewing From Afar

There is no doubt where Sarback was standing for this painting. She captures not only the beauty and character of the immediate and middle-distance vineyards, but the feel of great distance in the background.

CHABOT VINEYARD, NAPA
Susan Sarback | Oil
30" × 48" (76cm × 122cm)

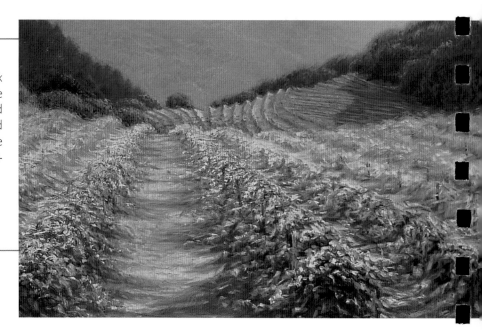

Looking Down at Your Subject
Lemire is looking down over the rooftops from the balcony of her third-floor apartment. From this vantage point, we see a world of shapes and textures not normally in our line of vision. The sun was setting behind a big pine tree and creating, in the artist's words, "astonishing pinks!"

A L'OMBRE DU GRAND PIN (IN THE SHADOW OF THE BIG PINE TREE) | Madeleine Lemire | Oil
30" x 36" (76cm x 91cm)

Composition Rules

There are traditional composition "rules," such as not placing the focal point dead center or in the corners of a painting, and not creating lines that will lead the viewer's eye out of the composition. But remember the danger of art rules: for every rule there is an artist who has successfully broken it in response to creative urges. Mastering the basics, however, will give you the know-how to break the rules intelligently. Your work can then appear original and fresh, rather than naïve and uneducated. Just as singers must learn scales and writers must learn vocabulary, artists need to absorb the basics of what makes good art in order to have all the tools of visual expression at their disposal. Study and understand the "rules" to use as guidelines. After gaining experience and developing confidence, you can work on solving painting problems in your own unique way to artistically serve your purpose.

Looking Up at Your Subject
Here the artist helps us appreciate the pines as they soar skyward by painting them from below eye level. One's viewpoint certainly can dramatize the landscape.

WINTER LIGHT | Joan McKasson
Watercolor | 17" × 19" (43cm × 48cm)

Zooming In on the Details

Lord chose to concentrate on a small section of wall and tile around a fountain instead of painting the entire fountain. This enabled her to focus on re-creating the beautiful richness of the shadow as it fell on the tile. Looking for an unusual angle of a scene can result in an original, refreshing painting.

FOUNTAINSIDE | Carolyn Lord | Watercolor
22" × 15" (56cm × 38cm)

Altered Viewpoint

Toms was interested in a subject that could be seen only from the river. She could not get as close as she wanted without actually being in a boat, but still painted the image as if she had been on the water. Understanding the techniques of perspective makes it possible to deviate from the actual view and still create a believable image.

TANKS | Leslie Toms | Oil
12" × 12" (30cm × 30cm)

Unusual Viewpoint

Now here is an unusual view. As the artist told me, "I love painting butts! It's what we usually see of an animal anyway." She turned this into a beautiful painting by the sensitive use of shapes and expressive brushstrokes. She then frames the center of interest with green gates, which she makes more interesting by making each side different.

THE GREEN GATE | Cheri Christensen
Oil | 30" × 30" (76cm × 76cm)

Painting From a Worm's-Eye View

Peggy McGivern | McGivern often uses unusual viewpoints that result in distortion of the figures to create humor and interesting views of everyday life. The painting in this demo is a good example of a worm's-eye view. Might this be what a small child sees when looking up at an adult?

MATERIALS

Surface
24" x 18" (61cm x 46cm) canvas-covered Gator board

Brushes
No. 2 filbert for original sketch and details • nos. 6 to 12 filberts for overall painting • no. 24 angle and bright for large areas • no. 6 bright for finishing and highlights

Oil Paints
Alizarin Crimson • Burnt Umber • Cadmium Orange • Cadmium Red • Cadmium Yellow • Cerulean Blue • Cobalt Blue • Dioxazine Purple • Lamp Black • Naples Yellow • Raw Sienna • Raw Umber • Sap Green • Titanium White • Ultramarine Blue • Viridian Green • Yellow Ochre

Other
Charcoal sticks for original sketch • Mist spray bottle • Paint thinner • Linseed oil

1 Make a Combined Contour and Gesture Sketch

All of the women I portray in my figure paintings are hardworking, and I usually show them from that working perspective. Here, the viewpoint is looking up at the figure or "hero" from the dirt of the earth, where her work is about to begin. The vast field between the figure and the distant homestead supports the idea that she has a busy day ahead of her.

For the initial drawing, I use loose, flowing gesture lines to capture the movement and more detailed contour lines in areas where I might later want to bring out certain details. Here, I use exaggerated gesture lines to create the body movement and more detailed contour lines to show the expression on the woman's face: a smile.

 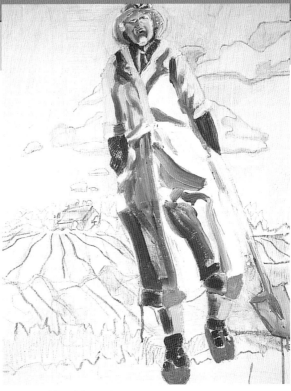

2 Mold the Figure With Shadows

I use the shadows to mold my subject. The shadow color I choose is to complement the colors I have in mind for the entire piece. In this painting, I use the opposite purple tones to complement the golden tones I plan to use for the woman's skin. If I wanted green highlights in the skin, I would use more red in the shadow color. I apply thinned paint to start creating the varied texture of the painting. Right now, I'm working only on the figure.

3 Build Bolder Color

Continuing to shape the figure, I gradually establish bolder colors that support the mood of the painting. For me, this stage is the soul of the painting. If I am excited about the piece now, I know I will have a successful composition.

At this point, I mist the painting with equal parts paint thinner and linseed oil. This gives me more working time and helps the flow of the paint. It also gives me the fluidity to "cut" into the figure with the background color to achieve more interesting final lines and shapes.

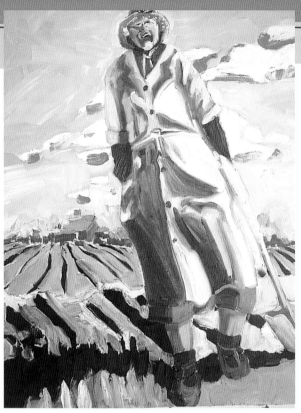

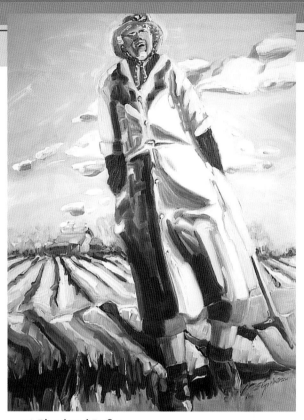

4 Develop the Surroundings

I introduce more color and connect the "hero" to the horizon line by bringing in some of the background and foreground colors and details. Because I feel I have a successful piece at this point, I believe that I can do no wrong as I fine-tune the color combinations. I have fully engaged the right (creative) side of my brain.

5 Blend and Define

Working on the foreground, the figure and the background together, I connect all the final colors by blending and defining lines to make the entire painting flow together. Although it's evident from her shovel and her surroundings that she has hard work ahead of her, the woman smiles contentedly as she prepares to conquer the tasks involved in her favorite day of the week.

GARDENING DAY | Peggy McGivern | Oil
24" × 18" (61cm × 46cm)

RHYTHM

The *rhythm* of a painting refers to the visual beat. It is what invites the viewer's eye to move about a painting in a regular or irregular manner. It can also visually communicate a sense of actual movement. Rhythm is created by the deliberate repetition of elements that may be the same or only slightly different. Repeating and arranging of shapes is the method most commonly chosen by artists, but repeating any of the art elements can create rhythm. Much like in music, the rhythmic tempo may be fast and abrupt or slow and calm.

What Are "Organizing" Principles?

Most sources call these "art principles" but I have chosen to use the phrase "organizing principles" to avoid confusion. For years, I struggled to remember the difference between art *elements* and art *principles*. Using the term "organizing" helps me to remember the difference between the terms. What are these principles? I have distilled them down to three: rhythm, balance and unity/variety. All are inherent in the art-making process. That is, you may not deliberately choose them; they simply are a part of any painting, even if done ineffectively. One of my art professors explained the relationship between art elements and organizing principles this way: "The art elements (line, shape, color, value and texture) are the ingredients, and the art principles are the recipe that determines how the ingredients are put together."

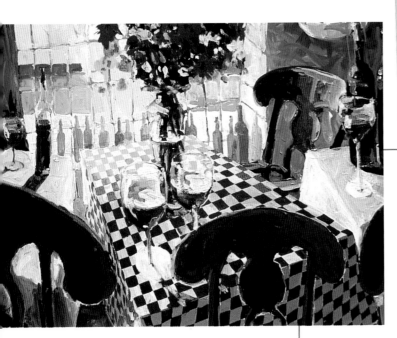

Repeating Shapes

The term *still life* can be deceiving! Burridge has organized this scene, which contains only inanimate objects, so that it invites the eye to move around the painting in a circular direction. He does this primarily through the repeated shapes and placement of the chairs. There is also the supporting, rhythmic repetition of the green bottles, the panes of the window and the rectangles in the tablecloth. Do you see other repeated shapes that add to the beat?

BISTRO ON THE BALCONY | Robert Burridge | Acrylic
30" × 40" (76cm × 102cm)

Fashioning a Flow

Kenyon creates rhythm with the repetition of the wine barrels as they recede and with the diagonal rows on the hill in the background. She also creates a flow with the shadows that start out dark in the foreground, then lighten and become spotty as they direct our eyes back and up to meet the dappled shadows on the barrels.

SAVANNAH WINE BARRELS | Liz Kenyon
Pastel | 30" × 24" (76cm × 61cm)

Creating Implied Movement

Connally creates implied energy, activity and movement in a number of ways: loose brushstrokes; the flowing rhythm of the curly hair; the flying ears of the dog in the background; and the angle of the fence. Placing the yellow ball in the dog's mouth hints at movement through our assumption that the pair will soon be engaged in a game with the toy.

FRIENDS AND YELLOW BALL
Connie Connally | Oil
40" × 30" (102cm × 76cm)

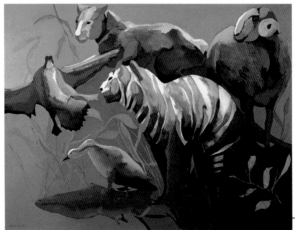

Reworking Reality

Embree has created a rhythmic design with the tiger's stripes, repeated in the curving shapes of the animals' backs. The bird in motion and the shapes of the leaves add to the sense of movement and rhythm. This is a good example of how an artist effectively places design above reality. Imagine how different this image would be if the traditional striped pattern were used.

WATERING HOLE | Anne Embree | Oil | 38" × 50" (97cm × 127cm)

115

Developing an All-Over Composition

Bonnie Casey | Casey paints the American southwest as she feels it. Her works, while filled with light and color, are straightforward depictions of the desert environment. Here, she creates an all-over composition of cacti in which she establishes an attractive rhythm in both the positive and negative spaces.

MATERIALS

Surface
22" x 28" (56cm x 71cm) Fredrix pre-stretched cotton canvas, with an extra layer of gesso

Brushes
No. 2 filbert (for initial sketch) • no. 8 filbert (for most of the painting)

Oil Paints
Alizarin Crimson • Burnt Sienna • Cadmium Green • Cadmium Orange • Cadmium Red Light • Cadmium Red Medium • Cadmium Yellow • Cadmium Yellow Light • Cerulean Blue • light blue (Cobalt Blue + Titanium White) • light yellow (Cadmium Yellow + Titanium White) • Portrait Pink • Shiva Flesh • Ultramarine Blue • Viridian Green • Yellow Ochre • White

Other
Turpentine

1 Get the Rhythm Going in the Sketch

I begin sketching with Burnt Sienna using free, gestural strokes. I sketch in a quick, spontaneous manner that isn't meant to reproduce the subject as seen, but to establish the overall position, rhythm and general growing pattern of the main subject forms.

A Word About My Palette

I believe that a full palette such as the one used here is necessary when depicting any subject with a full range of colors. I think that all three primaries, and the three secondaries mixed from them, should be used in every painting to some degree, unless your goal is a monochromatic scheme. Because I use the complementary system (opposite colors on the color wheel), a full range of complements is necessary to fulfill the need for graying the pigments used in the painting.

Work All Over the Canvas

I add thinned washes of various colors to begin establishing an environment for the prickly-pear cacti. I stay loose so that the subject can retain a spontaneous feeling. I work all over the canvas to keep it developing in a consistent manner, so the composition will hold together. At this point, I am searching for a color scheme that will reflect the beauty I see in the desert colors.

Develop the Cacti and Surroundings

Once I am satisfied with the general color scheme—warm light, cool shadow—and rhythm of the painting, I begin to define some of the cactus "paddles" with more color variations to create a sense of depth.

I add more color and thicker pigment where needed, watching the rhythm. I further define my image, making sure I do not get too focused in any one area. I want to keep an overall flow going as I develop the entire image in order to maintain unity.

Place a Few Details

Now that I have established the overall color and rhythm, I feel I am ready to start adding some details to settle the prickly pear into its environment: desert grasses, sticks, stones and so on.

5 Fill the Canvas and Create Depth
I continue to fill in and adjust the color to create a sense of depth. The white of the canvas is almost completely covered with color at this step. The grasses are further defined and the "eyes" of the prickly-pear cacti are added but kept loose and interesting on both the paddle face and their perimeters.

6 Make Rhythmic Marks
I add cool color to the foreground grasses to contrast with the warm colors of the main subject. I make more gestural grass marks to integrate the overall image. Note how the brushstrokes added to the yellow background pull this area together with the rest of the surface. This adds depth and creates more of a glow.

7 Develop the Details on the Cacti and Grasses
I enhance the grass and add color and stickers to the paddles. Now my attention turns to adding details to the paddles and grasses to further define the subject. I also continue to refine the colors and add different values so the paddles start to occupy their space more solidly.

8 Work on the Values and Details
I coordinate the background and foreground to make sure that the additional information stays true to my initial idea for the subject. I add more darks and lights to increase the value contrast and also continue to add detail and definition to the subject.

9 Finish the Background
The finishing background strokes are impasto, which can demand attention because of the extra paint and spontaneous manner in which they are applied. They tend to compete with the color of the focal area (toward the center of the painting) even though the focal colors are warm ones that naturally attract the eye. The addition of white in the background around the prickly pear cools those colors, creating a nice contrast.

COLOR OF THE DESERT | Bonnie Casey
Oil | 22" × 28" (56cm × 71cm)

BALANCE

Balance refers to the way art elements are arranged in a painting to create a sense of stability. It is achieved by equalizing the visual weight of different parts of your painting. This does not necessarily mean that you must use similar elements or objects on each side of a painting to balance one another, but rather that you should place the various art elements so that they create a *visual* equilibrium. For example, you might balance a highly textured area with a bright color; or a very detailed object with a large, simple shape. Your goal is to attain a sense of visual stability within the work.

Symmetrical Balance

With *symmetrical* (or *formal*) balance, the two sides of an image, when divided in half, mirror each other exactly. Symmetrical balance is commonly seen in fabrics and wallpaper, but is rarely used in fine art.

Visual Balance
This painting is a good example of achieving balance through different but visually equivalent elements. Przewodek balances the heavy foliage on the right side with a more saturated color on the left. Can you imagine how lopsided the painting would feel without the red tree? Cover up the tree and you will see! The visual weight of the bright color is equal to the large, rather neutrally colored shape.

SONOMA SQUARE | Camille Przewodek | Oil | 20" × 16" (51cm × 41cm)

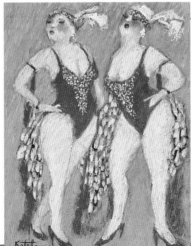

Similar, But Not Symmetrical
At first glance you might think this is an example of symmetrical balance because the two women are dressed identically. But notice the differences in hair color, positioning of the heads, and the body stances.

BIG IS BEAUTIFUL | Carole Katchen | Pastel 25" × 19" (64cm × 48cm)

Asymmetrical Balance

With *asymmetrical* (*informal*) balance, the two halves of an image do not mirror each other but have equal visual weight. Each half is organized to harmonize with and visually balance the other through conscious placement of the art elements. Asymmetrical balance can be accomplished by using contrasts in value or color, or by manipulating the weight of shapes through proportion, texture, complexity or intensity of color. Deciding where to position your visual elements in relation to one another is key to achieving balance in your composition.

Achieving Balance With Value
The huge cloud formations are definitely the center of interest in this painting. The detail, various shapes and value changes draw our attention. Lord balances the clouds with the darker, heavier mass of the ground. Yet, because the details are kept to a minimum, the ground does not compete with the clouds. Notice how Lord connects the ground and sky planes by painting a light-value shape on the background hill.

AUGUST AFTERNOON | Carolyn Lord | Watercolor
22" × 30" (56cm × 76cm)

Radial Balance
In radial balance, the subject matter and/or elements all radiate out from a common central point. Here, all the flowers radiate out from the vase. The lines of the stems are the true gems in this painting, as they lead the eye through the composition in a lyrical way for the viewer to enjoy.

LES ÉPHÉMÈRES (THE EPHEMERAL)
Madeleine Lemire | Oil
30" × 40" (76cm × 102cm)

UNITY AND VARIETY

A good painting achieves balance between *unity* and *variety*. Too much unity can be boring, and too much variety can create a disjointed and confusing image. Neither extreme holds the viewer's attention. Many artists have tried to explain this concept; there are even "rules" to achieve it, but it can also be achieved intuitively. Most of us have been agitated by chaotic situations just as we have suffered the boredom of uniformity. The way to save ourselves from chaos or boredom in life and art is to create a cohesive whole.

Once again, we are on a continuum. Moving toward either the high or low range of the unity-variety spectrum can serve you in communicating your ideas. For example, if your intent is to portray chaos, confusion and disorganization, you might go wild with variety. On the other hand, if your intent is to express serenity and calm, then greater unity would reinforce your message. However, somewhere along the continuum lies a zone which is both settled and interesting, unified and diverse. It is there where nothing can be added or subtracted without upsetting the balance of the composition.

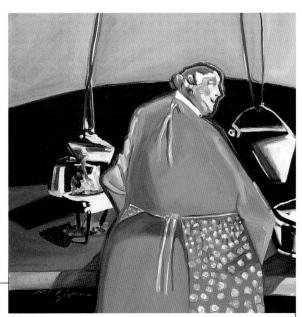

Unifying With Shapes and Details
McGivern achieves unity in this image with the harmony of the color scheme and because the objects she depicts are all related to cooking. She creates variety by using interesting and varied shapes: the asymmetrical showing of the apron, the curve of the back wall, the dropping away of the right shoulder, and the varying distance between the two sets of apron strings on the woman's back.

FLOWERED APRON | Peggy McGivern | Oil
20" × 20" (51cm × 51cm)

Unifying With Line
The varied values and colors of the flowers, leaves and background are unified by the stems that weave in and out of this all-over radial composition. The slender lines of the stems also contrast with the round, full shapes of the petals for added interest.

OCTOBRE JAUNE (YELLOW OCTOBER) | Madeleine Lemire | Oil
36" × 48" (91cm × 122cm)

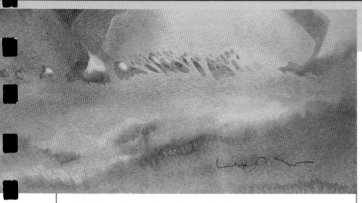

Unifying Through Color and Value

Kemp creates unity here with the consistency of the color scheme and the narrow value range. Variety is achieved in the variations of negative shapes and accents of contrasting colors and values. The elongated format adds impact and interest to the image.

LANDSCAPE MIRAGE NO. 4 | Linda Kemp | Watercolor
11" × 30" (28cm × 76cm)

Ways to Create Unity and Variety

There are numerous ways to use the elements of art to express your visual voice and find the point between unity and variety that feels right for you. Here are a few examples:

- **Line:** How many lines do you use? In which directions do they go? Do you draw with great deliberation or with quick movements? Do you want your lines to appear agitated or smooth and flowing?

- **Shape:** Do you repeat shapes? At what intervals? What are their sizes? Do you use biomorphic or geometric?

- **Color:** Do you choose colors that shout or colors that whisper? Do you use contrasts of temperature, hue and/or saturation, or a quiet monochromatic color scheme?

- **Value:** Are your values closely related or strongly contrasted? Do you create a flow of the major value shapes or do you place them randomly?

- **Texture:** Is the texture or pattern strong and dominating or subdued? What purpose do the textures serve? Are they contrasted with smooth, quiet areas?

Lemire

"In certain pieces there is inevitably a center of interest ... But we must not forget that in any painting, the negative space is as important as the subject itself."

MADELEINE LEMIRE is a French-Canadian painter whose delightful abstract and colorful landscapes reflect her enthusiasm and joy for life.

How do you plan your composition and begin a painting?

The first sketch is like a dance. I use charcoal at the beginning because it's easy and fast. It's also practical if I need to erase. Oil sticks are also useful for sketching. The movement appears in the first rough sketch. I start with the design for that particular painting. I do it for myself, but the viewer's eye follows the same pattern as the artist's. The painting should not be overworked, however, or the spontaneity gets covered with layers of paint. If there is too much detail, the viewer's eye gets lost. The painting gets too close to photography. I believe that sometimes painters go too far.

How do you guide the viewer's eye in your paintings?

I create lines that lead to a spot of interest that I've chosen for my subject. This is the center—not dead center—where the eye will come. This could be a dark building, a light flower, anything. The eye is also guided by the light in a painting. Here, subtleness is important.

Do you emphasize a particular center of interest or use more of an all-over interest?

In certain pieces there is inevitably a center of interest, like flowers or buildings. But we must not forget that in

Rhythm and Movement

Many of Lemire's paintings feature poppies. As she explains, "In the spring in the south of France, when you discover a field of poppies, it's very striking." She likes their combination of fragility when picked, yet strength to resist the wind when left to grow. She fills this image with rhythm and movement in the placement of the flowers, the shapes of the stems, and the curving brushstrokes throughout. The flow is emphasized by the sprays of red poppies that seem to move across the canvas.

COQUELICOTS (POPPIES)
Madeleine Lemire | Oil
36" × 48" (91cm × 122cm)

124

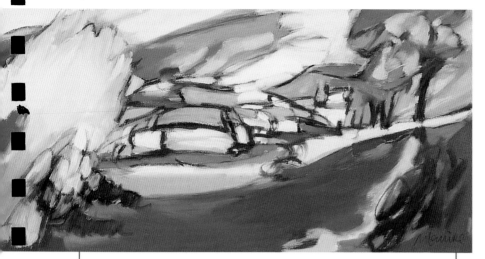

Capturing the Wind

Here, Lemire wants to portray the unusual winds unique to the south of France. Coming from the north, the wind divides as it approaches the Mediterranean and then moves in two directions: east and west. This creates almost a whirlwind effect, and it has been claimed that people have gone crazy after spending too many days in this wind. The forms in the village and the trees are painted out of shape, as if caught in the wind. Lemire explains that she did this painting "in one gesture" and "with energy" to make it sort of a "tourbillon" (whirlwind).

BLÉ MISTRAL (WIND ON WHEAT) | Madeleine Lemire | Oil
20" × 40" (51cm × 102cm)

any painting, the negative space is as important as the subject itself. Its relationship with the main forms is important. I believe that background is as important and as difficult to create as the details and centers of interest. The negative space must be in the painter's mind because it helps the observer see the interesting details.

Do you prefer a particular viewpoint for your images?

The viewpoint differs from one painting to another. I'm thinking like a cameraman in a cinema when I choose my position. I might be below, looking up at the subject, making it a hero. I often use this position when painting flowers, placing a bouquet high on a shelf. But other times, I place it on the floor.

It can also be at eye level. When I'm painting villages in the south of France, I like to have trees disappearing in the background because this adds mystery to the ambience. Instinct is what tells me where to stand and where to place the subject.

What advice would you give readers for solving their compositional problems?

The best tool for achieving good composition is one's instinct. Painters must be loose and nurture confidence in themselves. Practice by doing preliminary sketches to establish value, light and shape. This helps the composition. You must also feel the direction and movement of the painting. Try as much as possible to stay inside the painting, bringing all the elements together so they have close interrelationships. I think the center of interest is important, as well as keeping the shapes together and putting them into a pattern.

Vary the size and shape of the elements of the painting. Nothing is more boring than a bouquet of flowers done in the same size, color and position. The exceptions are when the painting is for decorative purposes and repetition is important. Or when the purpose is to evoke emotion; for example, through the vibration of colors. An example of this would be red and white stripes. And, finally, one well-known trick to see if the painting is balanced is to turn it upside down while you're working on it.

REVIEW AND REFLECT

QUESTIONS

1. What is the center of interest in each image? Do any use all-over composition? Which organizing principles—rhythm, balance and unity/variety—are emphasized in each? (Answers on page 128.)

2. Look at the formats and dimensions of each painting (their exact sizes are listed on page 128). How do you feel they support the subject matter?

3. Note the viewpoint used in each image. How do you think the image would be affected if a different viewpoint were used?

4. Which images feel the most balanced to you? What does the artist do to achieve this balance?

A ☐

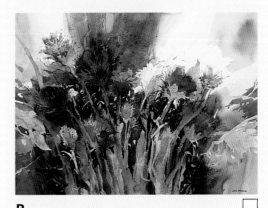

B ☐

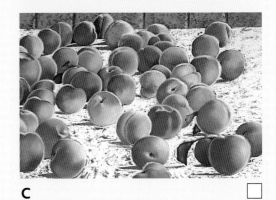

C ☐

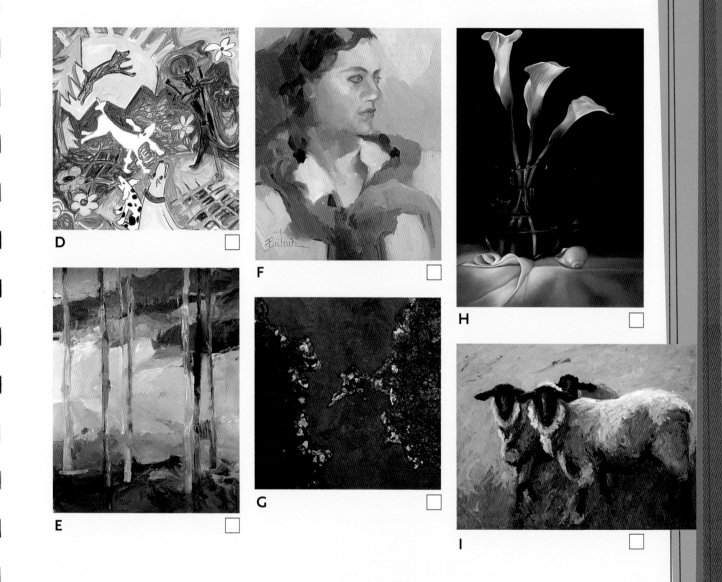

D

F

E

G

H

I

127

ANSWERS TO QUESTION 1

I have listed only a few points; there are others you may find as you study the images.

A *Street Scene*, Camille Przewodek, oil, 9" × 12" (23cm × 30cm). The focus is on the shape created by the three red umbrellas. Complementary greens in the foliage and buildings accentuate the intensity of the red. The repetition of umbrella shapes creates a rhythm that pulls the two sides of the painting together while adding variety to the image.

B *Thistles Growing Wild*, Joan McKasson, watercolor, 22" × 30" (56cm × 76cm). The limited palette of color unifies this all-over composition, and value contrast adds variety and organizes the major shapes. Extending the dark values diagonally across the canvas and repeating that diagonal movement in the angles of the stems results in a dynamic image that, although it is a still life, has a sense of movement and great speed.

C *Peachy Keen*, Liz Kenyon, pastel, 25" × 32" (64cm × 81cm). In this all-over composition, unity is created by the fact that all the objects are peaches. But, no two peaches are the same in color or position. The peaches in the lower-right corner—the only ones with leaves—lead the eye into the image without becoming the center of interest.

D *Bark in the Park*, Cristina Acosta, acrylic and pastel, 30" × 22" (76cm × 56cm). Some may call this an all-over composition, but I find my eye drawn to the white dog against the purple. The eye is led from the lower-right corner and then up and around the painted forms in a circular manner. The repetition of dogs adds unity, but the variety of breeds adds interest. The image has a lot of implied movement.

E *Greenwood*, Barbara Rainforth, oil, 60" × 48" (152cm × 122cm). In this all-over composition, a rhythm is created by the repetition of the tree shapes, but no two tree trunks are the same—they vary in shape, color and placement. Horizontal land shapes and vertical trunks create an interesting counterbalance to each other.

F *Sweet Sixteen*, Cynthia Britain, oil, 12" × 10" (30cm × 25cm). The sweater and hand lead us up to the center of interest: the face. The sweater, hand and hair are simplified to keep them from competing with the face. The sweater has a gen-tle, simplified rhythm that is reinforced by the hair braids. A vertical format supports this quiet moment of reflection.

G *Kemet/Deshret No. 9*, Helaine McLain, acrylic with mixed media, 12" × 12" (30cm × 30cm). The center of interest is the interesting shape that extends into the blue. Unity is created by the similar handling of the color and texture of the shapes on either side of the blue. Varying the shape, color, and texture of the shorelines adds variety.

H *Beginnings Call*, Nicora Gangi, pastel, 18" × 14" (46cm × 36cm). The graceful, fragile-looking flowers form the center of interest. Notice the arc created by the flowers. Balance is maintained by the placement of the shell on the table. Imagine the absence of the shell and see how the visual balance is lost.

I *The Three Fates II*, Cheri Christensen, oil, 36" × 48" (91cm × 122cm). The center of interest is the unique dark shape created by the three faces. The body of the front sheep also has the greatest value contrast. The overall harmony of the color scheme creates unity. The repetition of the sheep makes it a more interesting image. Imagine the two smaller sheep removed and you will see what I mean.

THOUGHTS ON QUESTIONS 2–4

NOW IT'S YOUR TURN

EXERCISE 1
EXPERIMENT WITH EDGES

The edges of the picture plane are the four most important lines of your composition. Try doing four drawings or paintings of the exact same subject on four different formats: a vertical rectangle, a horizontal rectangle, a square and another shape of your choice.

- How does changing the format of the edges impact the composition?

- Did one work better than the others? In what way?

EXERCISE 2
CENTER OF INTEREST — OR NOT

Carefully consider a number of your paintings.

- Do you paint with a strong center of interest or an all-over composition?

- Do you feel the approaches you used best expressed your visual voice?

 Try varying your usual approach. For example, select a subject and paint it first with a strong center of interest, then using an all-over composition.

EXERCISE 3
VARIOUS VIEWPOINTS

Experiment with different viewpoints—above eye level, at eye level and below eye level—in a series of drawings or paintings of the same subject. Try using an everyday object, such as a jar. How does your perspective change the effect of the piece?

 Now select a more complex, but ordinary subject and zoom in on a particular aspect or choose an interesting viewpoint from which to draw or paint.

EXERCISE 4
LEARN BY EXAMPLE

Look at a number of paintings by established artists. If you don't have access to museums, study art books, Internet images or monographs on individual master painters. Focus on the organizing principles used in the paintings. Draw a simple outline of the main components in several paintings to study the composition of the images, and consider the following questions:

- How does the format support the image?

- Does it have a center of interest? What does the artist do to attract the eye to it?

- Does it have an all-over composition? How does the artist direct the eye?

- How does the artist keep your eye within the painting?

- What is the viewpoint? Does it add particular meaning to the painting?

- How does the artist use the organizing principles of rhythm, balance and unity/variety?

5 DISCOVER YOUR PAINTING PROCESS

You may have heard it said that in a creative endeavor, it is the process, not the product, that's important. I puzzled over this statement for a long time before I understood that it is in the doing that we learn, respond to challenges and grow. The product is a painting we can hang, sell, give away, put away or even destroy—but our active involvement is over. No more learning occurs until we move on to the next painting.

The painting process is everything you do as an artist to produce a painting. It includes planning and preparation as well as the act of painting. Part of the joy of the artistic process is that it is never static. Madeleine Lemire, who has been painting for many years, says that she still gets very excited about new ideas and materials. The examples of her work that appear in this book demonstrate her fresh and lively approach. Many of the other contributing artists mentioned that leaving their comfort zone to face new challenges is an essential part of their process.

> "Things are not difficult to make; what is difficult is putting ourselves in the state of mind to make them."
>
> —CONSTANTIN BRANCUSI

Part of the painting process includes the methods you use to apply paint to your chosen surface. There are a variety of techniques available to express your artistic message. Good painters, however, warn against becoming a slave to technique and "style," believing that doing so stifles creativity. William (Skip) Lawrence addressed this when he said, "There are too many people producing art that lacks soul and personality because it is based more on rules and techniques than on personal feelings."

How do you want to start?

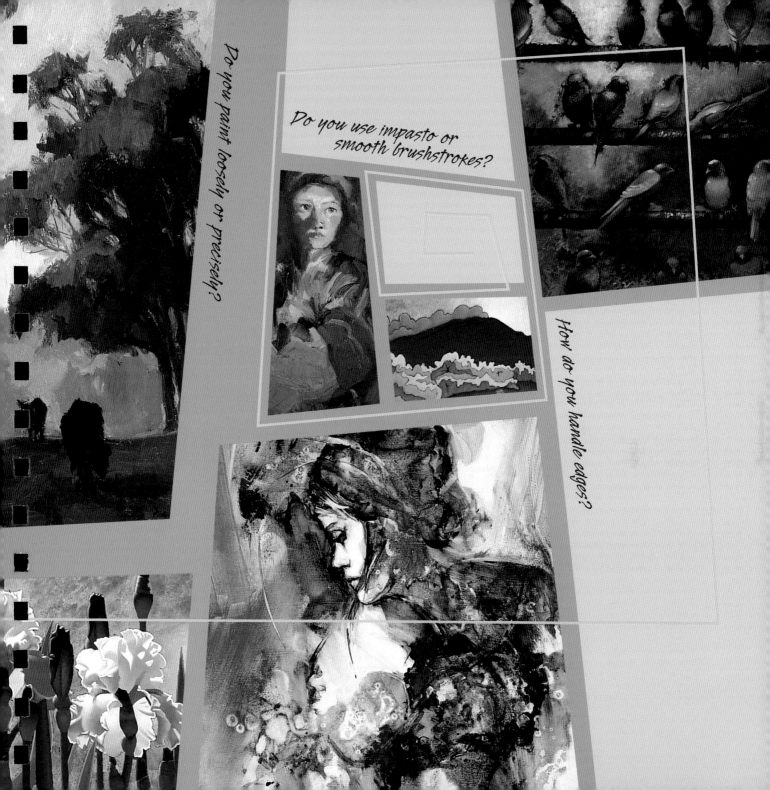

Do you paint loosely or precisely?

Do you use impasto or smooth brushstrokes?

How do you handle edges?

FINDING YOUR MEDIUM

Discussions about painting techniques in other books or in classes are usually related to the technical aspects of a particular medium, such as watercolors or acrylics. But most of the information in this chapter applies to all mediums. You may discover that the way you prefer to paint or the effects you want to achieve influence the medium you choose. For example, you may initially be attracted to watercolors, but then discover that you want to experiment with the impasto technique (applying paint thickly on the surface). This might encourage you to try oils.

I have experimented with most mediums: I started with watercolor, changed to acrylic, and then moved to oil. I've also worked with soft pastels, oil pastels, inks, gouache, oil sticks and encaustics—you name it, I've tried it! I kept searching for the "perfect medium," but finally learned that each one has its advantages and disadvantages. I realized that the important thing is to find the medium whose characteristics best suit what you want to achieve. I encourage you to experiment with various mediums, then follow your intuition when choosing your medium and techniques. (Read more about the qualities of various popular mediums later in this chapter.)

Taking Advantage of the Medium
In this image, Casey uses the qualities of oil to their fullest to create a striking painting of a beautiful desert sunset. Oils allowed her to apply overlapping layers of paint to capture the spectacular evening light as it hits the clouds.

DESERT SUNSET | Bonnie Casey | Oil
18" × 24" (46cm × 61cm)

"An artist's style will be the sum of his or her philosophy, interests, and personality, among other things, but will be arrived at via their technique."

—ROBERT K. ABBETT

PREPARING TO PAINT

Sometimes an idea will grab you and you can hardly get to the canvas fast enough to start a sketch. Other times, facing a blank canvas can be intimidating. The contributing artists in this book suggested a variety of ways to approach a painting session:

- Set a schedule for painting. "You can't wait for the mood," Susan Sarback says.

- Wake up your senses with an early-morning walk.

- Meditate. One artist described mentally descending in an elevator until she reached a level that felt right; another uses meditation to "get out of her own way."

- Set the tone by listening to music.

- Do warm-ups in the form of small, quick paintings.

- Recite a mantra, such as "If I paint, I don't hesitate. If I hesitate, I don't paint."

- Visualize your process.

- Get out of your thinking mode and connect with your feelings. Try to re-create the emotion experienced the first time you saw a scene you now want to paint.

"In art intentions are not sufficient.... What one does is what counts and not what one has intentions of doing."

—PABLO PICASSO

Painting Warm-ups
Burridge starts every morning in his studio with a few small paintings before starting the "big painting" of the day. Choosing a different subject each day, he spends about half an hour "having fun." Even though their original purpose was to prime the artist, these warm-ups now sell well in galleries.

PRIMAVERA | Robert Burridge | Acrylic
36" × 24" (91cm × 61cm)

GETTING STARTED

How Do You Want to Begin?

There is no one right way to start a painting. Some artists like to jump right in and start painting immediately, feeling that this enhances their creativity and expressiveness. Others do preliminary sketches to plan their composition, or value and color studies to free up their creativity once they begin painting. Many artists report doing preliminary studies during their early years while they were gaining experience, but doing fewer or none at all as the painting process became more intuitive.

Your personality and work preferences will guide you in finding the approach that works best for you. Try both approaches and note how you feel during the process. Hitting the canvas right away will exhilarate some of you and unduly stress others. Likewise, preliminary planning will free some and bore others.

How Do You Approach Your Subject?

Some artists prefer to paint directly from their subjects, while others prefer to work from their imagination, or from sketches or

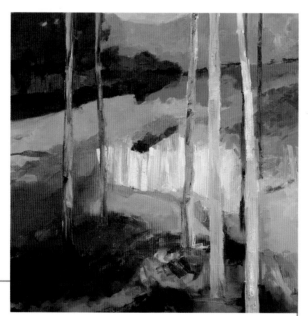

Starting With Studies
Rainforth does not paint directly from the landscape. Instead, she takes numerous photos and creates collages with them in various arrangements, looking for color and line notations that encourage her to paint. As she works on a painting, she uses the collage as a reference.

WILD ROSE TRAIL | Barbara Rainforth | Oil | 48" × 48" (122cm × 122cm)

other reference materials. Artists who do not work directly from their subjects, especially those with years of experience, may rely on memory to provide them with the information they need to create a painting. A common practice is to use photos as reminders and references for composition ideas, light and details. They are especially helpful when working with subjects such as flowers that wilt, or outdoor scenes where the light changes rapidly. A few artists in this book reported using multiple photos to create a collage from which to paint. Sketches are particularly useful for capturing figures, which—except in the case of models—are not static.

What's Your Method of Working?

How do you work on the various parts of a painting? Many artists work all over the canvas, developing the image as a whole rather than finishing any one section before moving on to the next. If you study the demos included in this book, you will see that all the featured artists used an all-over approach as they produced their paintings. Other artists may complete one section at a time. But, if you choose the latter approach, be careful to maintain the overall harmony of your piece.

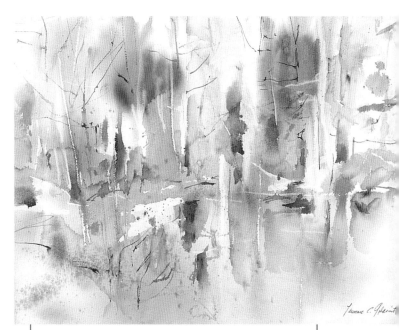

Painting by Simplifying the Subject
Some artists prefer not to paint directly from nature because they find the details distracting or overwhelming. Goldsmith, however, was able to distill the essence of a scene on-site with minimal strokes. This resulted in exquisite designs, as in this image where he conveyed the pond's reflections with horizontals that defined the edges and by the directions of the reflected shapes and lines.

DEER POND | Lawrence Goldsmith | Watercolor
18" × 24" (46cm × 61cm)

Painting With an Emphasis on Drawing
Bradley draws constantly and strongly believes this discipline is essential to learning to simplify, as she has done in this image. Here she simplifies plums to their essential characteristics, including the white cast around the large plum. This touch reminds me of the frosty white that plums often have on their skins.

PLUMS | Jen Bradley | Oil | 24" × 18" (61cm × 46cm)

135

BRIAN DAVIS

"My ideas come from observation. I commonly have a camera with me. When I see something that I believe is artistically exceptional, I stop what I'm doing and take shots."

PHOTO BY RICHARD CARTER

BRIAN DAVIS is known for his magnificent flowers, painted with an eye to revealing the play of light on their petals and their exquisite details.

How do you choose the flowers that will be your subjects?

My ideas come from observation. I commonly have a camera with me. When I see something that I believe is artistically exceptional, I stop what I'm doing and take shots. I'm a visual prospector who is constantly on the prowl. While I'm working, I'm asking myself, "What is the most elegant way to represent this subject? What is the hidden beauty that is commonly overlooked? What is worth saying that hasn't already been said a million times?"

What is your painting process for capturing the beauty of flowers?

My process starts with photos. The kind of image I find most interesting to paint can take weeks to produce. Obviously, if a flower wilts in a day or two, I need either a great memory or a photo to paint from. In some cases, I start a painting working from life and finish using a photo. A drawback to

Freezing a Moment in Time

Davis often works for several weeks to complete his images. He uses photographs as references to enable him to capture the freshness and beauty of flowers.

PINK AND WHITE CACTUS ORCHID
Brian Davis | Oil
24" × 30" (61cm × 76cm)

Planning for Perfection
Observing the lovely detail, light and shadow captured on these blossoms, one is not surprised that Davis spends time planning and designing his images before starting to apply paint to the canvas.

DAHLIA DUET | Brian Davis | Oil
30" × 40" (76cm × 102cm)

using photos is that they can add contrast that makes the dark areas in my subject darker and the lights lighter. So I take numerous shots to get the best exposure of each of the various elements in my composition. I prefer natural lighting on my subjects, but I commonly paint until late at night so using photos has been important.

The painting procedure I use is a common one. I start on a toned surface, lay in a grid, sketch in my drawing, paint in the darkest areas and then the lightest parts, thus creating a value painting. Next, I begin the more detailed painting, applying color going from general to specific.

What got you focused on painting flowers?

Through the years, I have painted many different subjects including landscapes, portraits and nudes. But the floral direction is one that I particularly love. The actual process of making art has nothing to do with the subject matter. If I made eleven rose paintings in a row, all of them would be different. In each one the shapes, colors, edges, backgrounds and visual ideas would be unique. Creating strong art, in my opinion, is a matter of being clear about the concept of the painting and assembling the components in a way that makes the painting concept strong. My job as an artist—to create compelling works—is the same no matter what I paint, but floral ideas just keep flowing out of me.

How have your paintings changed over time?

As I age, I find that I am drawn to a painting style which is more paint-

erly, with more expressive brushwork. Although my work is tighter than John Singer Sargent's, for example, I enjoy the way he applies paint. There is a charm in being able to see the mind of the artist at work in the strokes of the laid-down paint.

How do your personality and your approach to painting reflect each other?

I have a strong desire to excel. I want to feel the thrill of doing something well, whatever I'm doing. Working hard has never been a problem for me. I'm always striving to make paintings that are satisfying to me personally, and I'm willing to put in the effort needed to achieve that result.

137

MOVEMENT: CONTROLLED OR LOOSE

I'm sure you've noticed a distinct sense of movement in many paintings. What you may not realize is that this effect is often produced by the actual body movements of the artists as they work. The amount of movement is influenced by how much of the body you use as you paint: hand and wrist, arm and shoulder, and so on. The more physical involvement, the looser the strokes.

The degree of control or looseness you should use depends on how you want to express yourself. The control continuum runs from precise to loose. If you want precision in a piece, your brushwork is likely to be more controlled. At the other end of the spectrum is a more gestural application of paint. The term *gestural* refers to making marks with relaxed body movements. If you want broad, loose strokes, your entire body might be involved in making free, expansive brushstrokes. Speaking of looseness, some of the artists in this book have said they find themselves dancing as they paint!

Control is also affected by how you hold the brush. The closer to the *ferrule* (metal collar) that you grasp the brush, the more controlled your strokes, because this position limits the movement of the arm and shoulder. The farther back the brush is grasped, the more body movement that occurs, resulting in looser strokes.

Achieving Precise Beauty
This level of detail requires Davis to be precise, but he achieves a delicate and beautiful image without any feeling of tightness. Davis's work is a good example of linear technique, which places importance on the outside contours and outlines of the shapes and edges of the flowers.

THREE PINK DAHLIAS | Brian Davis | Oil
36" × 24" (91cm × 61cm)

Less Precision

Although the shapes in this work are defined by outlines, they are not painted in a detailed manner. Varied in size, shape and texture, the interiors of the shapes are loosely expressed. The more casual application of paint creates a much different effect than the smooth, controlled brushwork in the painting on page 138 by Brian Davis.

FIRST SNOW | Vince Gasparich | Oil pastel
12" × 12" (30cm × 30cm)

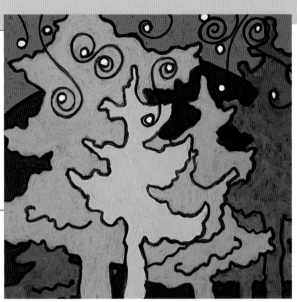

Loose and Flowing

This painting moves farther along the continuum toward looseness. Note the fluid manner in which Toms painted the hillside, trees, buildings and skies. Rather than using lines and edges, Toms creates her forms with a painterly approach, emphasizing textured patches of color and variations in value.

LESLIE TOMS | Hill Town—Tuscany | Oil
8" × 10" (20cm × 25cm)

Precise Does Not Mean Tight

The goal of many painters is precision. They want to represent their subject—or at least certain aspects of it—in as detailed a form as possible. Tightness, as the term is used in art, results in a painting that appears overly controlled and stiff. It is not the same as precision—or even necessary to achieve precision. In fact, most painters struggle to loosen up. There is a tendency, especially by beginning painters, to attempt to control all aspects of their work, resulting in tension that is reflected in the painting. Even if you are doing fine detail, you don't have to be tense or tight.

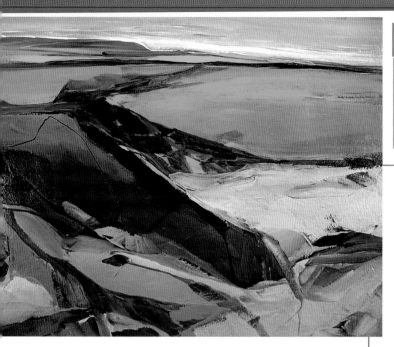

Try this experiment: Draw a line very slowly, carefully and deliberately. Now draw another line very rapidly and freely. You can see from the results that the speed of your movement is recorded on the surface. It is the same when you are applying paint.

Capturing Movements on Canvas

The pleasure that Rainforth took in painting this scene is evident to the viewer. You can sense her whole body engaged in movement as she applies thick, intense colors to the canvas to capture the essence of the scene. Patches of color, rather than lines and edges, create the painterly effect.

BEACH HORIZON 11 | Barbara Rainforth | Oil
20" × 30" (51cm × 76cm)

Combining Loose and Controlled Strokes

Kenyon loosely paints the background, but achieves contrast by using more controlled strokes to capture the shapes and postures of the birds.

SOCIAL HOUR | Liz Kenyon | Pastel | 25" × 30" (64cm × 76cm)

Staying Loose

If you find yourself tightening up when you paint, try taking a break to walk around. Scan your body for any feelings of tenseness. Try stretching or deliberately tensing and then letting go to relax these areas.

Leaving Canvas Unpainted

Lemire leads us into the image with loose, expression-istic brushstrokes. The bare canvas in the foreground provides a restful space that contrasts with the intense activity of the background. She integrates the two spaces by extending shapes and lines down onto the bare canvas. These also serve to lead our eyes back to the shapes in the top half of the painting.

LE CYPRÈS (THE CYPRESS) | Madeleine Lemire | Oil
36" × 48" (91cm × 122cm)

The Truth About "Effortless" Paintings

Artists whose paintings are enjoyable to view because of their seemingly effortless brushstrokes may, in reality, strive mightily to achieve this effect. John Singer Sargent is one of those artists. When he described his process of painting, it was anything but effortless. He removed and reapplied his paint numerous times until he got that "loose and effort-less" look, making the difficult look easy.

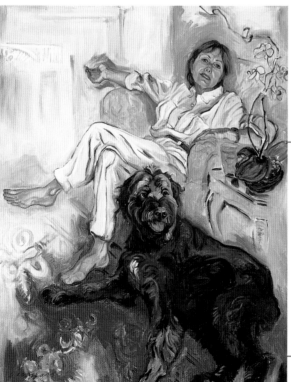

Focusing on the Subject by Minimizing Detail Elsewhere

In this painting, the figures of the woman and her dog in this painting are the only areas completely covered. The room surrounding the figures is roughly sketched with line alone. Do you see how using minimal detail in the background focuses attention on the subjects of this por-trait? This technique also creates a sense of looseness to the painting.

PATTI PYLE AND CHLOE | Connie Connally | Oil
60" × 48" (152cm × 122cm)

APPLICATION TECHNIQUES AND MEDIUMS

The terms *smooth* and *impasto* refer to the artist's method of applying paint, as well as to how the surface of a painting would feel to the touch. Some artists like to paint in an impasto manner, laying down thick, buttery, separated strokes using a brush or palette knife. Van Gogh, for example, used lush impasto brushstrokes in his paintings. You can actually feel the roughness of an impasto painting. Other painters prefer to create a smooth surface with even transitions that de-emphasize their brush marks.

Surface texture is an individual preference and something you can experiment with. Great art is most likely to be achieved with the technique that best fits the subject and intent of the artist. Your relationship with art materials will develop from your personal preferences in subject matter, emotional content and work habits. Joan McKasson, one of the artists featured in this book, likes the movement and unpredictability of working wet-in-wet with watercolors because it is like raising her four children: never a dull moment!

The type of surface texture you want to obtain will dictate, to some degree, the medium you choose. For example, painters who enjoy rough, impasto surfaces will not be able to achieve this with watercolors. On the next couple of pages are a few words about the most commonly used painting mediums.

- **Oil** is naturally thick and can be used right out of the tube to create an impasto effect. Oil also

"Paint should not be applied thick. It should be like a breath on the surface of a pane of glass."

—JAMES MCNEILL WHISTLER

"In a single brushstroke we can say more than a writer in a whole volume."

—EDGAR DEGAS

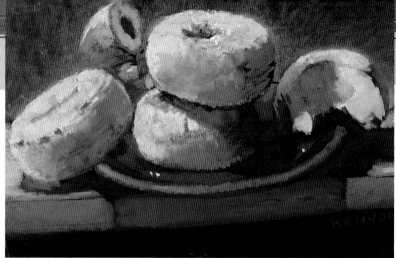

Suggesting Texture With Pastel

By not overblending but instead allowing separate strokes to show on the donuts, Kenyon creates powdered sugar that is nearly tangible. This technique works well with this subject because it creates an effect you can almost taste.

DONUT BREAK | Liz Kenyon | Pastel | 12" × 16" (30cm × 41cm)

Creating Moderate Texture With a Palette Knife

Sarback often paints with a palette knife, but she does not apply her oils as heavily as Christensen and other impasto painters. She is closer to the middle of the continuum between impasto and smooth.

EUCALYPTUS GARDEN
Susan Sarback
Oil | 16.5" × 11" (42cm × 28cm)

Creating Smooth Surfaces With Oil

Bradley uses brushes rather than palette knives to create a smoother surface with oils, although she keeps her brushstrokes separate and not overly blended to add interest to the surface. She uses medium to thin her paint and then applies layers of the resulting transparent glaze to create a luminous surface.

PINK BOWL | Jen Bradley | Oil
48" × 36" (122cm × 91cm)

Creating Rich Texture With Impasto

Christensen does not dilute her oil paint with medium, so it stays thick and spreads on like butter with the palette knife. This technique is characteristic of all her work.

OH...PEAR | Cheri Christensen | Oil
16" × 20" (41cm × 51cm)

143

Creating a Polished Surface With Pastel
Gangi applies pastel smoothly, using her fingers to blend. She rubs many layers into sanded paper to achieve the polished finish. This effect works well with this subject because it enhances the theme of reflection. As Kenyon did with her donuts, Gangi has chosen the technique that best achieves her artistic intent.

ONE REFLECTS THE OTHER | Nicora Gangi | Pastel
10" × 7" (25cm × 18cm)

can be diluted with medium to smooth the painted surface or to create thin, transparent glazes. Oils can even be diluted enough so they can be poured onto the surface, though this technique is rarely used. Oil paint is also available in sticks shaped like thick crayons. They work well for drawing directly on the canvas; they can be blended with mineral spirits or by other means to achieve a less linear appearance. Contributing artist Madeleine Lemire frequently works with oil sticks.

- **Acrylic** has less body and is more transparent than oil. It requires an additive to create the same degree of raised surface texture that is natural for oil. Water or other mediums can be added to increase the flow or to create thin, transparent glazes. With greater dilution (or with the use of liquid acrylics), acrylics can be poured onto the surface.

- **Watercolor**, by its very nature, is smooth and transparent (although the addition of white pigment can create opacity, such as in gouache). It is the only medium that moves "with a life of its own" when working wet-in-wet (wet medium on wet paper). It doesn't dry to a permanent surface, so it cannot be worked over repeatedly as with oil and acrylic.

- **Oil pastels** lend themselves to creating with lines because they come in sticks rather than in a tube. They also may be worked with a brush dipped in mineral spirits for a smoother, blended effect. When oil pastels are not blended, they have some texture, but not to the point of true impasto.

- **Soft pastels** are also in a stick form. They are chalky and create a fine dust as they are applied. Blending is not done with a medium, but with the fingertips, paper stumps (also called *torchons* or *tortillions*) or cloth.

Building Up a Surface With Multiple Strokes

Gasparich uses layers of oil pastel to build up a rich surface and create some texture. This is best seen in the blue sky, where individual strokes are visible. True impasto, however, is not possible with oil pastel unless surface ridges are built up with a medium before applying the pastel.

TAOS VALLEY | Vince Gasparich | Oil pastel | 24" × 18" (61cm × 46cm)

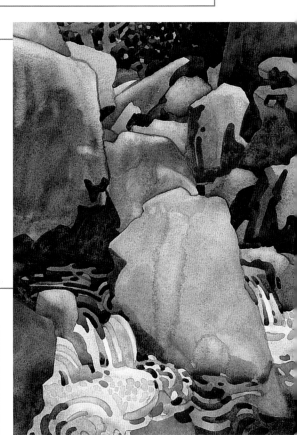

Simulating Texture With Sedimentary Pigments

While Goldsmith exploits the smooth surfaces natural to watercolors, Lord uses pigments that settle out when dry to create the grainy texture on rocks. This creates the illusion of a rougher surface, although there is no raised paint as in impasto.

STEPPED FALLS | Carolyn Lord
Watercolor | 15" × 11" (38cm × 28cm)

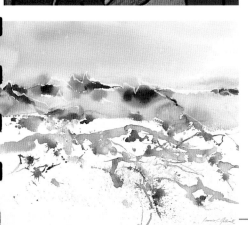

Varying Watercolor Techniques for a Dynamic Smooth Surface

Goldsmith captures the turbulent coastline and crashing waves in watercolor by working wet-in-wet to paint the soft, smooth areas of the top half of the image. While the first layer is still damp, he drops in the bolder accents and lifts paint to form the edges of the whitecaps. For more control over the lower half, he applies paint to a dry surface in various ways, including dropping and spattering. He shows us that even though watercolor results in a smooth surface, it can portray the dynamics of a very active sea.

DEFINITION: COAST | Lawrence Goldsmith | Watercolor | 18" × 24" (46cm × 61cm)

"In Chinese painting, I use brushstrokes and lines. In my watercolors, there is more emphasis on shapes and not as much use of line."

LIAN ZHEN is a bicultural artist who creates images using either watercolor or traditional Chinese painting techniques. His work is exhibited in the United States and China and he teaches both styles in workshops all over the world.

You create two kinds of paintings, Chinese and watercolor. Can you describe Chinese painting?
There are three styles. The first is the detail style in which, as the name implies, you paint everything in detail. You outline objects and then add six to fifteen layers of color. The second is spontaneous, which is done without sketching. There's no going back in this style. If anything goes wrong, you start another painting. And the third is a combination. The focal point is done in detail style, and then the background in spontaneous. I myself like the spontaneous style best.

How are the techniques in Chinese and watercolor paintings different?
In Chinese painting, I use brushstrokes and lines. In my watercolors, there is more emphasis on shapes and not as much use of line. Also, the materials are completely different. Chinese painting uses ink and rice paper and, of course, its own type of paints. On the other hand, in watercolor I use regular watercolor materials and only three primary colors to paint.

I had understood that Chinese painting uses only black ink, but you use colors in your rooster demo (see page 152).
In that painting, I did use black ink a lot, which is common in Chinese painting. Then I lightly used Yellow, Vermilion, Carmine and Rouge. Chinese pigments are water-soluble but different in composition from watercolor. They have more glue in them. This makes them less [suitable for]

Choosing a Medium for Desired Effects
Here Zhen uses thick ink and bolder strokes to portray the power and ferocious nature of this animal protecting her cub. Notice how he emphasizes the muscular aspects of the tiger's body and exaggerates the paws to look more ominous.

TIGER | Lian Zhen
Ink and Chinese paints
24" × 38" (61cm × 97cm)

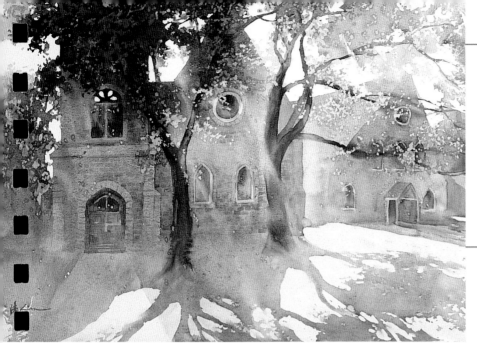

Going With the Flow
This is a good example of maximizing the qualities of one's medium. Zhen uses the flow and transparency of watercolor to capture the ethereal qualities of his subject.

CHURCH | Lian Zhen | Watercolor
21" × 29" (53cm × 74cm)

blending but stronger [at] attaching on the rice paper. Rice paper warps after painting, so you have to stretch it by completely soaking the painting, then attaching another layer of rice paper at its back. Watercolors on rice paper would run during the stretching process.

How do you use layering and handle edges in watercolor?
In watercolor I try not to paint more than three layers because it's too easy [for the color] to get dirty. I don't like painting all transparently or opaquely. Instead, I love the contrast created by using both transparent and opaque paints. To create the opaque effect I apply thick pigments. I vary the edges, too. Working with a lot of water will soften edges, and working drier creates sharper edges.

How do you decide what kind of painting to paint?
I like to paint more original work in watercolor because I've created my own style. With Chinese painting you have to be familiar with brushstrokes and objects. If only one or two brushstrokes are wrong, you have to start over. Even though I keep only about half of my spontaneous-style Chinese paintings, I love to do them and I want to share my knowledge of this traditional style.

How do you get ideas for your paintings?
Ten years ago I tended to look at objects and copy them. I painted what I could see. Now I paint what I want to see. To paint grapes in watercolor, for example, I started pouring the three primary color liquids on paper to create grapes, wines and leaves. It's very free. Nowadays I "go with the flow."

I also take pictures and then paint from them, making a composition from several pictures. Sometimes I paint on location. For the last four years I have taken groups to China and sketched there. I love to do the color pouring and blending in my studio.

How do the techniques you use contribute to what you want to say visually?
I want to express beautiful things. I want people to be happy, to enjoy life and to enjoy nature.

147

Painting Impasto With a Palette Knife

Cheri Christensen | Christensen creates rich, tactile images of animals. You can almost feel their feathers, hair and fur! "You can see how much texture you can impart with the palette knife, which I use for the entire painting," she says. "I also like the rhythm it brings to the painting."

MATERIALS

Surface
24" x 30" (61cm x 76cm) Gessobord

Oil Paints (Gamblin Artist's)
Alizarin Crimson • Cadmium Red Light • Cadmium Yellow Deep • Ivory Black • Phthalo Blue • Phthalo Green • Titanium White • Yellow Ochre

Other
No. 2 hog bristle brush (for initial sketch only) • Palette knife • Venetian Red gesso (Daniel Smith) • odorless mineral spirits (Gamblin Gamsol)

1 Apply the Underpainting and Make a Sketch

I start with a plain Gessobord and apply an underpainting using Venetian Red gesso. Then I do a rough sketch with my brush to create the overall composition, including shadow areas. I redo my sketch until I have it just the way I want it, with interesting positive and negative shapes. If you look closely, you can see that I've moved the rooster slightly to the right, placing it more in the center of interest. This repositioning also increases the overlap with the foreground chicken, which gives more depth to the painting and helps to connect the big shapes.

Block In the Shadows

Even though the chicken is white, it still has a shadow side, so I block it in with the rest of the shadows. The point is to keep the shadows together, separating them from the light.

Continue Placing the Shadows

I continue working on the shadow areas, connecting wherever possible. I like to finish all of the shadows before I start the lights. I don't make up the colors used, but I may push them compared to what the initial scene had. As I do this, I judge the colors against each other: light or dark, subdued or bright, warm or cool. My goal is to retain the color relationships presented by Mother Nature in this scene. I continually correct the work until it looks right.

Develop the Lights

I start working on the lights now, keeping them in the middle range so I can add highlights and accents to them later. I adjust the color as I did in the shadows. Notice how I've kept to the big shapes, leaving details until the end.

5 Sparingly Add Details

I add the highlights to the chickens, doing a slight bit of modeling on the form and clarifying the details. I like to keep my paintings loose and leave something for the viewer to fill in, so I purposely don't put in a lot of detail.

Detail: The Head in a Few Strokes

See how few strokes it takes to give detail to the head, and the buildup of texture with the palette knife. The knife enables you to place warm and cool tones on top of one another without the colors becoming muddy.

Detail: Colorful, Unblended Strokes for Feathers

A palette knife allows you to use a lot of paint to achieve broken (not blended) color. The strokes are not one solid mass but are made up of many colors. This effect with only slightly mixed paint lends itself well to the feathers on chickens.

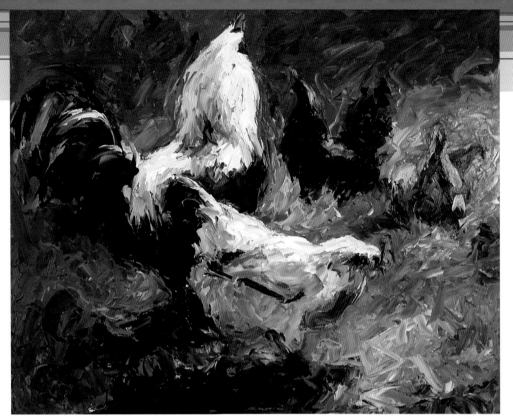

6 Add the Finishing Touches

I add only a few touches here: a few more highlights on the grass to bring the chickens together, and more detail on the back chickens. And it's done!

THE JOURNEY HOME | Cheri Christensen | Oil
24" × 30" (61cm × 76cm)

Avoiding Muddy Colors With Impasto

When you are applying paint in an impasto manner for a complementary color scheme, it is important to lay the colors down in such a way as to not mix them together. In this painting, for instance, the chickens have red combs that stand out against the green grass, and the blue reflected from the sky onto the white chicken complements the warm orange reflected on the bird's underside. If these complements were mixed together during application, muddy colors would result, spoiling the color scheme.

Capturing Texture on a Smooth Surface

Lian Zhen | Zhen has mastered both watercolor and Chinese painting styles. In this demonstration, he captures the feathery body of a rooster using ink and water-soluble, colored Chinese paints.

MATERIALS

Surface
15" x 10" (38cm x 25cm) single-layer Shuan paper

Chinese Brushes
One small (similar to a no. 2 round) and one large (similar to a no. 12 round)

Chinese Paints
Carmine • Rouge • Vermilion • Yellow

Chinese Ink
Black

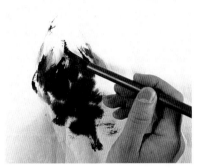

1 Sketch the Neck and Chest
I wet the large brush a little and pick up light ink (diluted with water) on its tip and middle. In a few strokes, I sketch the neck and the chest. Then I use dark ink to add more strokes on the neck and chest while the light ink is wet. I avoid using a lot of water and ink, because it will blend too much.

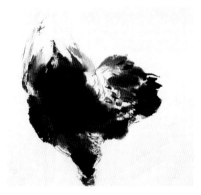

2 Paint the Thighs and Body
I use the same brush to paint the thighs and body. At the wing, I've mixed Rouge with a little ink to make a brownish color for depicting the feathers. I leave areas of the paper white for highlights and to create feather textures.

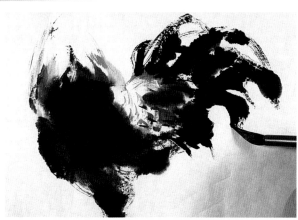

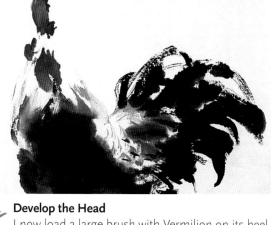

3 Paint the Tail Feathers

Now I paint the large tail feathers with the large brush. I load the tip and middle of the brush full of dark ink and, using the side of the brush, apply a single stroke for each feather.

4 Develop the Head

I now load a large brush with Vermilion on its heel, Carmine in the middle and a little Rouge on the tip. I dab the brush on my palette so the colors blend into each other. Holding the brush slightly sideways, I paint the rooster's comb, ear and wattle.

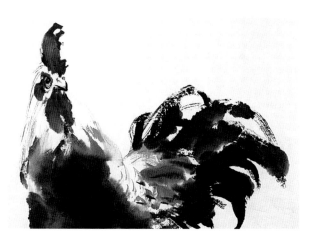

5 Add Detail to the Face

I pick up some dark ink with the small brush and paint the beak, eye ring and pupil. I add a few short strokes at the bottom of the comb, around the ear and on the upper part of the wattle. Then I use Yellow and Vermilion to paint the eyeball and the tip of the beak.

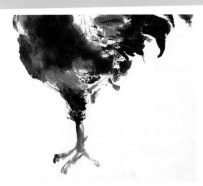

6 Add the Legs
I mix a small amount of Rouge and ink with the large brush. Holding the brush straight up, I paint the feet and toes using the tip.

7 Detail the Legs
When the colors on the feet and toes are about 60 percent dry, I use the small brush to paint the textures of the feet and toes and the claws with dark ink.

ROOSTER | Lian Zhen
Ink and Chinese paints
15" × 10" (38cm × 25cm)

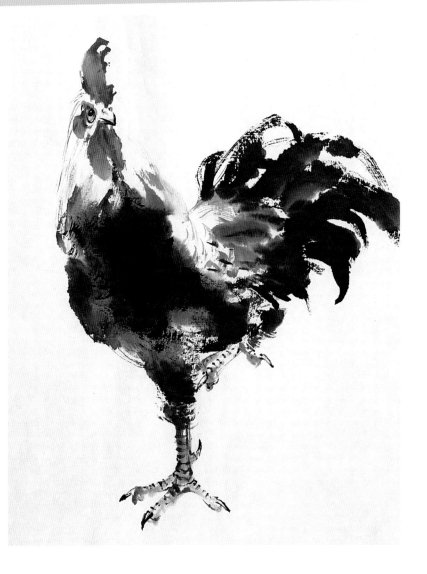

EDGES: SOFT OR HARD TRANSITIONS

Painters create *edges* wherever they place two different values, colors or textures next to one another. Some artists like to paint soft transitions between shapes, allowing the colors to blend together. Others prefer hard edges that show distinct differences in color, texture or value between the shapes. Most artists use the full spectrum of edge treatments from hard to soft. Like everything else in art, it's an individual preference. Great art has been created at each extreme and everywhere in the middle.

Different types of edges are used for different reasons. For example, you might choose to create hard edges around the center of interest and softer edges in the rest of painting to achieve a variety of interesting transitions. Painters often use soft or lost edges to pull together and mass similar values to prevent the isolation of shapes, which can result in a cutout look.

How Edges Speak

As you search for your own visual voice, consider the character of various edges through these vocal analogies:

- **Hard/sharp edge:** The voice raised to its maximum volume, shouting to get attention. This is the highest level of visual contrast, sharp and crisp.

- **Intermediate edge:** The voice speaking in its normal range. The edge is moderate, modulated and transitional.

- **Soft edge:** This is much like a whisper. One brushstroke blends into another. Your eye can see the transition, but it is soft and gradual.

- **Lost edge:** The voice isn't even audible. The transition isn't seen clearly because it is so gradual.

Using Lines to Define Edges
Gasparich defines most of the hard edges in this landscape with lines. He makes an exception in the sky above the mountain, which is defined with the hard edge of a dark value against the lighter value and softer texture of the sky. He paints the sky using a smooth transition of values, starting with the lightest right behind the dark mountain, then progressively darkening toward the edges of the painting. This emphasizes the glow in the sky as the moon rises over the mountain.

MOONRISE | Vince Gasparich | Oil pastel
14" × 20" (36cm × 51cm)

Colors of similar value can be laid next to each other to add visual interest within one shape. The edges of these colors will be distinguishable only when viewed closely; from a distance, the hues will appear to blend together to create added vibrancy.

Creating effective edges, of whatever type, is an important skill to master because edges can make the difference in whether a painting is unified and "looks right." This is true even for nonrepresentational paintings, because well-conceived, enhancing edges help orchestrate the path of the viewer's eye as well as add variety and interest to the work. Hard edges attract and slow the eye, while soft or lost edges encourage the eye to move along with little interruption. You can achieve a great variety of effects using different types of edges in your paintings.

Soft Edges

Watercolor is a natural medium for creating soft edges. McKasson works wet-in-wet so that the colors take on a life of their own as they merge and blend with surrounding wet areas. Notice the large shape formed by the multiple white flowers. The edges are hard enough to define the individual flower heads, but they softly merge together into one shape. With her mastery of edge control, McKasson creates a cohesive whole and avoids the cutout look so often seen in flower paintings.

POPPIES IN MY GARDEN
Joan McKasson | Watercolor
22" × 30" (56cm × 76cm)

Lost Edges

This is a good example of lost edges. You know there has to be an edge between the right shoulder and face, but you cannot actually see it as the shapes disappear into the background. This is an approach used by artists to anchor the painting to the background and to avoid a cutout look. Do you see how this technique creates a certain mood as the figure emerges out of the shadows?

EXOTIC BEAUTY | Cynthia Britain | Oil
16" × 11" (41cm × 28cm)

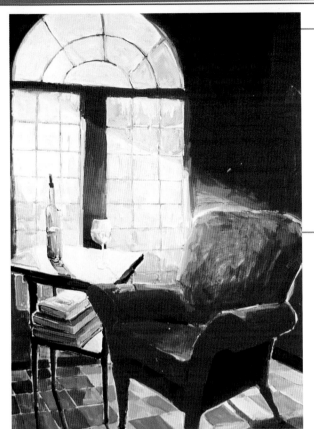

Using a Variety of Edges

Burridge uses hard edges to define the windows, table, chair and floor, but intermediate and soft edges to re-create the light in the sunrays on the back of the chair. He captures the character of each object, such as the comfort of the chair and the solidity of the table, through a variety of edges as well as colors, textures, values and proportions.

RED CHAIR | Robert Burridge | Acrylic
60" × 48" (152cm × 122cm)

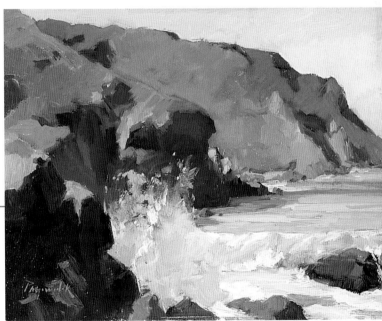

Using Edges to Create Depth

Przewodek uses edges in this image to create a sense of distance. Notice that the closer cliffs have harder edges, the middle cliffs have intermediate edges, and the far cliffs have soft edges. This demonstrates atmospheric perspective, in which details grow less distinct as they move farther away from the viewer.

SHARK HARBOR SURF | Camille Przewodek | Oil
12" × 16" (30cm × 41cm)

LIZ KENYON

"People look at their paintings and don't know what's wrong. And I say, 'look at your edges.'"

LIZ KENYON changed her direction as an artist eight years ago. After a noteworthy career in illustration and advertising, she began working with pastels and has achieved success as a fine artist. Edges, she maintains, are critical to any painting's success.

How would you describe your technique and process?

I would say I'm more painterly than linear. I try to layer and build up a texture. I start with just a vague field of color and cover the page. I like to get chalk all over my surface first, and then the conversation starts. I block things in and then I can start reacting to the surface. Do I like that color? Do I like that shape? I may place the piece in front of a mirror so I can react to the shapes and values. Sometimes I'll turn the room lights really low so I can see the values and determine if they're the ones I'm reaching for. If the value is right, the colors aren't important. At the end, I go in and see if there's enough contrast at my focal point. I'll ask myself: Should I say more about it? Will the viewer see what I see? Is there anything more I should do to make things come forward?

Describe your layering process a little more.

I use thin layers, but I do build up in subsequent layers to create texture. One thing I've always been striving for is not to lose indications of my process on paper. Even though I know I want to end up with a blue sky, I start with scratching marks of colored pencil in anything but blue. For example, I might start with the complement of blue, which is orange. In the end I'll put in a layer of blue. I always allow holes so the viewer can see the layers that created the painting. I've seen artists who show their process on the paper. Some viewers may think these are mistakes, but it makes the work more visually interesting.

Creating Special Effects With Soft Edges

Kenyon's use of soft edges lends itself to showing how the first light of morning looks as the sun comes up behind trees. This effect is called *backlighting*.

MORNING WITH OAKS | Liz Kenyon
Pastel | 18" × 21" (46cm × 53cm)

What kind of edges do you tend to use most often, and how do you use them in your work?

Edges are really important. You can do a whole book on edges. People look at their paintings and don't know what's wrong. And I say, "Look at your edges." I personally love soft edges. When I see hard edges, my stomach sinks. If there is a hard edge, it has to be a short stroke—a highlight or decorative stroke. I blend edges or make them bumpy. For example, I like to wear wrinkly cotton clothes rather than crisp linen. Right now I'm looking at a painting I did of a mountain that has a straight, hard edge. I want to change it, but it was professionally framed!

How do you decide which colors to use?

My mind tells me. I know what will happen to colors. I bring in all the colors because it's fun for me. Maybe it's more sophisticated to paint in a more monochromatic palette. I just can't bring myself to do that. Even when I start that way, the painting just doesn't have enough energy for me. I like the full spectrum. I want to use as many colors as possible. That's just me. That's what makes my style.

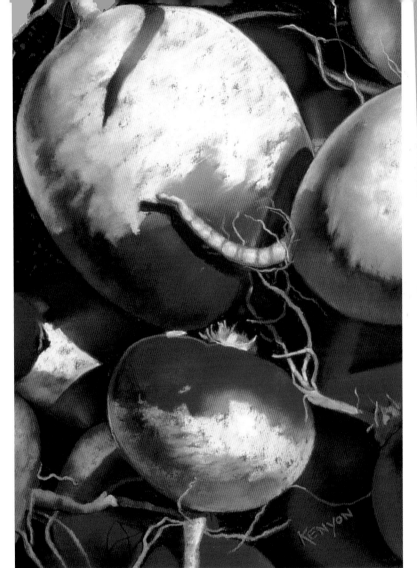

Using a Full Range of Edges
Kenyon uses all types of edges to create this striking image. Hard edges define the turnips, while soft and intermediate edges are used to model the contours. The lost edges help hold the turnips to the picture plane and prevent a cutout look.

TURNIPS | Liz Kenyon | Pastel | 19" × 13" (48cm × 33cm)

159

ADVICE FROM PROFESSIONAL ARTISTS

The artists who contributed to this book were not only generous in sharing their work, but also in giving suggestions and advice. Here are some of their pearls of wisdom that I hope you find inspiring and of value as you pursue your artistic journey in search of your own visual voice.

"Create a supportive group for yourself."
—CRISTINA ACOSTA

"Maintain a daily connection with your ideas and your personal mark-making. You can achieve this with just one thirty-second drawing a day." —JEN BRADLEY

"Trust your instincts and find your own way. Learn from artists you admire personally and professionally. And lastly, don't be hard on yourself as you discover who you are and how to best express it." —CYNTHIA BRITAIN

"Paint what's in your heart. It's never too late to be what you should have always been." —ROBERT BURRIDGE

"If you're painting from your emotions, it's your visual self." —BONNIE CASEY

"Collect samples of everything you like, things that move you. Take them home and analyze what it is that moves you… look for the 'Aha!' Then do it your own way." —CHERI CHRISTENSEN

"You need a dedicated space where you paint, even if it's a corner of the living room. When you put things away, you put your art life away. Make a space for your art." —CONNIE CONNALLY

"Take classes from people who are technically gifted. Get a profound grasp of the technical side." —BRIAN DAVIS

"Talent is helpful, but it is the constant working that moves an artist to a new level. Also, don't fight your true self." —RHONDA EGAN

"The most important thing is to not worry about selling your art. Just play. Play with all the materials. So much of what makes a painting beautiful is the accidents." —ANNE EMBREE

"I am interested in painting the sublime, that aesthetic experience of being overwhelmed and filled with awe at something so majestic that it evokes a sense of the eternal." —NICORA GANGI

"Just stick with whatever looks and feels right to you. Try lots of things and see what might fit you best." —VINCE GASPARICH

"I stress the value of simplicity. That one clear response, the message behind the painting, should sing out loud and strong. Select the essence of what you are painting and leave out all extraneous detail." —JEAN GRASTORF

"I believe that every artist has his or her own vision of the world; our job as artists is to find and express that vision. The most important thing is to keep exploring, yourself and your materials." —CAROLE KATCHEN

"Don't worry about being influenced by others, because this is natural. But you need to make it your own so you can go on." —CARLA O'CONNOR

"Time to paint isn't something you find, it is something you need to make." —LINDA KEMP

"Keep a book of clippings of paintings you really like, such as unusual compositions and good designs." —CAMILLE PRZEWODEK

"Accepting yourself is where you find your fulfillment." —LIZ KENYON

"Try to stay out of your own way. The biggest challenge is this." —BARBARA RAINFORTH

"The best tool for good composition is one's instinct. Painters must be loose and nurture confidence in themselves." —MADELEINE LEMIRE

"Your nature should dictate how you paint. You may love a painting and a painter, but it might not be you. Everyone has a certain greatness; your greatness is your uniqueness developed. So you have to discover your uniqueness." —SUSAN SARBACK

"To thine own self be true." —CAROLYN LORD

"Work hard and get the basics." —MARILYN SIMANDLE

"Remember that you are not painting a picture, you are creating a painting." —PEGGY MCGIVERN

"At times, put yourself in uncomfortable situations with your artwork. Enrich your life with experiences." —SHAWN SNOW

"You paint your heartbeat. You have to follow what you respond to, not what you think someone else expects from you." —JOAN MCKASSON

"You have to make yourself uneasy at times to make a painting successful." —LESLIE TOMS

"Paint often and joyfully." —HELAINE MCLAIN

"Learn to love nature and love life. If you appreciate life and nature, your paintings will show this." —LIAN ZHEN

REVIEW AND REFLECT

QUESTIONS

1. For each painting, is the feeling more loose or controlled? (Answers on page 164.)

2. For each painting, what types of edges does the artist use? (Answers on page 164.)

3. What effects do you see created by the artists with their choices of level of control, types of edges and paint application techniques?

✅ WHAT SPEAKS TO YOU?

Check the boxes next to the paintings that appeal to you most.

- What is it about these paintings that appeals to you?

- What is it about the unmarked paintings that is less appealing to you?

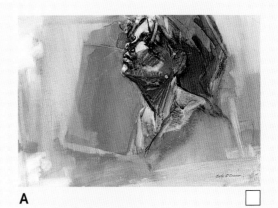

A

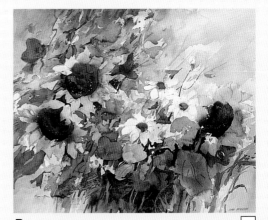

B

C

162

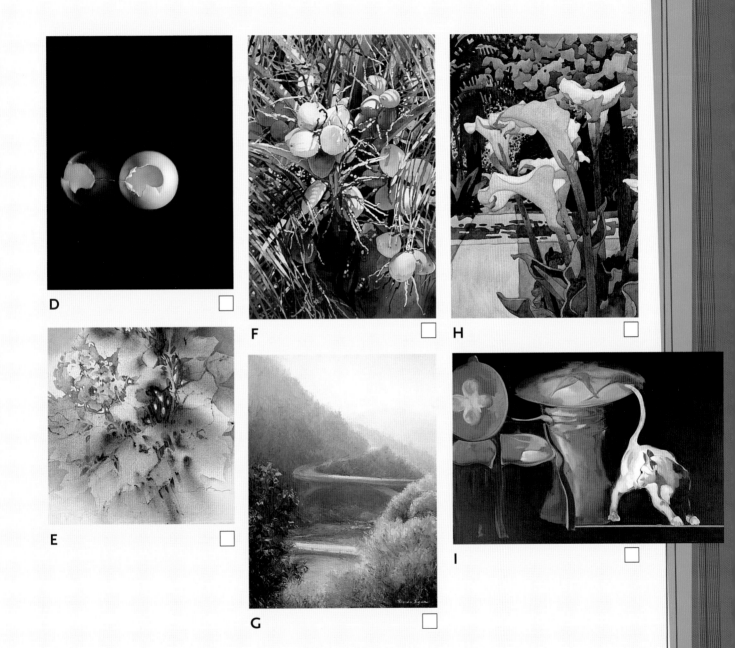

D

E

F

G

H

I

163

ANSWERS TO QUESTIONS 1 AND 2

I have only listed a few points; there are others you may find as you study the images.

A *Favorite Model*, Carla O'Connor, gouache, 15" x 22" (38cm x 56cm). This image has a very loose feel to it, but the ability to accurately depict the shapes in the face requires very practiced control. The full range of edges is used: hard in the hair, soft and intermediate in the neck area, and lost in the left shoulder.

B *Sunflowers, Daisies and Poppies*, Joan McKasson, watercolor, 20" x 26" (51cm x 66cm). This artist likes the spontaneity of working wet-into-wet and reinforces this spontaneity by the loose and dynamic arrangement of a variety of flowers. The edges are crisper in her center of interest, then soften as she moves away from it.

C *Salflay*, Cheri Christensen, oil, 16" x 20" (41cm x 51cm). This artist uses a palette knife to spread the paint on in thick impasto strokes. Her approach creates a loose feel, but also notice the accuracy of the placement of the features. This requires control to maintain the believability of the subject. She uses the full range of edges: hard to define the face and ears against the dark background; intermediate and soft to create the body; and lost to suggest the hind quarters and feet.

D *From The Very First*, Nicora Gangi, pastel, 14" x 15" (36cm x 38cm). It takes a great deal of control to render the delicate details of the broken egg shells. There are many hard edges, but also notice the soft transitions on the shells and the lost edge of the back egg shell.

E *Summer Light*, Linda Kemp, watercolor, 11" x 11" (28cm x 28cm). This image has a loose feel to it, but the details required control and precision. The loose feel is supported by the number of soft edges, but hard edges strongly define some of the shapes.

F *Southern Breeze*, Jean Grastorf, watercolor, 40" x 30" (102cm x 76cm). This artist often starts her paintings by pouring watercolor, then uses subsequent layers to define the detail. This may first appear as a very well-defined subject, but the full range of edges is used.

G *Over the River and Through the Woods*, Rhonda Egan, oil, 20" x 16" (51cm x 41cm). This is close to the middle of the controlled/loose continuum. The edges are sharper in the front and soften in the background to increase the sense of depth with atmospheric perspective.

H *Sidewalk Divas*, Carolyn Lord, watercolor, 22" x 15" (56cm x 38cm). This is a more controlled image due to the well-defined hard edges. This artist paints primarily in hard edges by allowing the previous layer to dry before applying the next layer. But notice the areas in the flower heads where soft transitions are used.

I *Observation*, Anne Embree, oil, 40" x 60" (102cm x 152cm). There is a looseness in the forms that adds to the charm of this image, but the objects are still precisely defined. The cat runs the gamut of edges: hard in the tail; soft and intermediate in the body; and lost in the chest area, connecting it to the background.

THOUGHTS ON QUESTION 3

NOW IT'S YOUR TURN

EXERCISE 1
GETTING STARTED

Have you developed ways to prepare yourself to paint? How motivating are they? Review the different methods suggested by the artists on page 133. Choose one to try as you begin your next few painting sessions.

EXERCISE 2
VARY YOUR APPROACH

If you normally start painting directly on the surface, try doing a preliminary study first. If you usually do preliminary studies or plans, try approaching the surface directly. How does the change in approach feel to you?

EXERCISE 3
HOW DO YOU MOVE?

Choose a subject to paint, then pay attention to your body and how much it moves as you work. Try changing the body parts and muscles you use to paint: (1) hand and wrist, (2) arm and shoulder, and (3) your whole body. If you normally sit when you paint, try standing. How do these changes affect your work? Do you find the results positive or negative? Notice also how the various ways feel, both physically and emotionally.

EXERCISE 4
HOW DO YOU HOLD YOUR BRUSHES?

As you paint, experiment with different ways of holding your brushes to vary the amount of control you have over your movements. Start by holding the brush very close to the ferrule and then experiment with moving your hand closer and closer to the end. Try applying an extension to the handle to achieve even looser movements.

EXERCISE 5
THICK OR THIN LAYERS

Do you prefer working with thick paint or with thinner layers? Or something in between? Does your technique support your intent? Create a series of paintings of the same subject in which you use different amounts of paint. How does each change affect the mood of the piece? Which effects speak to you artistically?

EXERCISE 6
THE EFFECT OF EDGES

Review a few of your paintings. What kinds of edges have you used? Choose one painting to do again, this time changing some of the edges. How is the painting different? Do the differences make the painting better for you?

SELF-ASSESSMENT SUMMARY

As you read each chapter, respond to the art, consider the questions in the Review and Reflect sections, and do the Now It's Your Turn activities, you will begin to better identify your own visual voice. Use these self-assessments for each chapter to summarize your feelings and discoveries about yourself as an artist. Explore these ideas further by writing your thoughts in a journal.

Chapter 1: Sources of Inspiration

Where are you on the source-of-inspiration continuum?
- ☐ at the internal end
- ☐ near the middle but toward the internal
- ☐ near the middle but toward the external
- ☐ at the external end

Chapter 2: Subject Matter

Which subject category or categories do you have the strongest response to and feel moved to paint (or to continue painting)?
- ☐ still life
- ☐ figurative
- ☐ landscape
- ☐ nonobjective

Where do most of your paintings fall on the realism-to-abstraction continuum?
- ☐ highly realistic
- ☐ realistic, but somewhat abstracted
- ☐ abstracted, but somewhat realistic
- ☐ highly abstracted
- ☐ nonobjective (or nonrepresentational)

Chapter 3: Art Elements

Which elements, in order of priority, do you feel would communicate your visual voice most effectively? Rank them from 1 to 5, where 1 is the highest priority and 5 is the lowest.

(Note: Generally, they cannot be given equal weight.)
__line __shape __color __value __texture

Chapter 4: Composition Style

Which statement best describes your thoughts about format?
- ☐ I prefer using traditional formats (rectangular or square-shaped).
- ☐ I prefer traditional formats but would like to experiment on occasion with unconventional shapes and arrangements (circular, diptych, etc.) and/or unusual dimensions.
- ☐ I prefer unconventional formats to traditional formats.

Are you interested in creating paintings within a series?
- ☐ yes
- ☐ not particularly
- ☐ maybe, if the suggestion comes naturally

Which statement best describes your opinion on creating a center of interest?
- ☐ I think it's important to establish a clear focal point in most (if not all) of my paintings by employing some kind of contrast and perhaps providing a visual path to lead the eye.
- ☐ I prefer an all-over composition to a definite center of interest.
- ☐ My preferred method for creating a center of interest usually varies from painting to painting.

Mark all the viewpoints that interest you for painting:
- ☐ straight on (eye level)
- ☐ worm's-eye view
- ☐ bird's-eye view
- ☐ close up
- ☐ from a middle distance
- ☐ from afar
- ☐ altered, uncommon and/or greatly distorted

Describe your thoughts about how you want to handle the following organizing principles in your paintings, including (1) where you tend to fall on the continuum of each, and (2) which art elements you envision yourself using most often to establish them:

Rhythm (fast to slow) _____

Visual balance (symmetrical to asymmetrical) _____

Unity/variety (highly unified to greatly varied) _____

Chapter 5: Painting Process

What medium(s) do you currently paint with or would you like to try?

☐ oil ☐ acrylic
☐ watercolor ☐ oil pastel
☐ soft pastel ☐ Other: _____

Which activities or processes do you want to try as you prepare yourself to start painting?

☐ meditation/visualization exercises
☐ listening to music
☐ going to a room dedicated to painting
☐ setting a schedule for painting
☐ painting warmups (small, quick studies or exercises)
☐ Other: _____

Which approaches do you feel would work best for you when creating a painting?

☐ painting from resource material (photos, reference books, etc.)
☐ painting while viewing the subject
☐ painting from memory
☐ painting from imagination
☐ doing preliminary studies
☐ sketching directly onto the painting surface

Where are you on the body-movement continuum while painting?

☐ very controlled
☐ somewhat controlled
☐ somewhat loose
☐ very loose

Which medium application techniques and methods interest you? Mark all that apply.

☐ impasto or somewhat thick brushwork
☐ smooth or fairly smooth brushwork
☐ painting mainly with transparent paints
☐ painting mainly with opaque paints
☐ wet on dry
☐ wet in wet
☐ creating actual texture on a painting
☐ creating implied texture on a painting
☐ focusing on a single medium for a painting
☐ experimenting with several mediums within one painting
☐ making or embellishing a painting with other materials
☐ Other: _____

Which statement best describes your thoughts about how edges can help you express what you want to say in your paintings?

☐ I use more hard edges than soft and lost edges in my artwork.
☐ I use more soft and lost edges than hard edges in my artwork.
☐ I prefer using a more even combination of hard and soft (or lost) edges in my artwork.

WHERE TO GO FROM HERE

Finding your visual voice takes commitment, time, and work. As with other worthwhile efforts, it's helpful to put together a plan of action. Although the suggestions here are divided into groups, they are not intended to be sequential steps. They actually work hand-in-hand. For example, listening to and respecting your internal voice are continual, lifetime goals. And learning requires taking action. So as you read through this section, consider how the suggestions might interconnect, then develop a plan that leads you where you feel you can go as an artist.

LISTENING

You need quiet time to hear your visual voice. When can you make time for yourself to reflect and listen without interruption? (Even ten or fifteen minutes a day is a good start.)

SUGGESTIONS FOR LEARNING

- Take a class or a workshop
- Sketch and/or paint daily
- Use books for self-study, such as collections of artists' works or creativity workbooks
- Work with an artist/mentor
- Study the work of the Masters
- Other:

LEARNING

Do you need to improve your drawing skills to best express your visual voice? Which of the "Suggestions for Learning" might best assist you with this?

What more do you need to learn about the art elements, compositional design and your medium(s)? Which of the "Suggestions for Learning" might best help you accomplish this?

You can learn a great deal about solving artistic problems by studying the work of other artists, especially the Masters. What sources of their work can you access?
- ☐ museums
- ☐ books
- ☐ magazines and journals
- ☐ Internet
- ☐ Other sources:_____

TAKING ACTION

Do you have a dedicated space, even a small one, to do art? If not, how can you create one?

Do you have a plan for accessing your subject matter? For example, if you want to do still life, will you set up your own arrangements? If doing figurative, will you paint from sketches or use models?

What amount of time are you willing to devote to your painting? What can you do to organize your life to ensure that you have this time?

What activities might help encourage you and inspire your creativity?

☐ spending time in nature
☐ listening to music
☐ studying the artwork of others
☐ creating with other artists
☐ traveling
☐ Other:_____

GAINING ARTISTIC COURAGE

Develop the courage to follow your visual voice by:

- reading about the lives of master artists to see the struggles they went through

- showing your work to others only when you are ready

- not fretting over the opinions of family and friends

- listening to and learning from teachers and other artists without accepting their word as "the way"

- recalling the wise words of Elmer Bischoff that were mentioned in the Introduction:

 Work hard. Learn the basics and put in the brush time.

 Take chances. Being afraid to take chances can lead to safe, boring art. Strive for a goal higher than simply creating a technically proficient image.

 Respect the validity of your imagery. You are unique in how you view the world and, if you allow it, this leads to unique images.

 Accept the struggle of the creative process. It is never easy when trying to learn and expand your world.

SEEKING SUPPORT AND STAYING POSITIVE

Many years ago, my sister talked me into taking a watercolor class with her. I can hardly describe how discouraged I was with my very first painting. There was no resemblance to the leaves the instructor had so attractively arranged for us to paint. I thought mine was definitely the ugliest painting in the class. My impulse was to leave and never pick up a brush again, but then my sister told me, "I like what you've done. It seems to have an Oriental influence." Her approval was just enough to get me to return to the second class. I still have that painting and I look at it now and erupt into peals of laughter. I owe my sister a debt of gratitude for saying just the right thing at the right moment, giving me the courage to continue pursuing my life's dream.

There are bumps in the road on every artist's journey. But staying on the path, whatever yours may be, is crucial to unearthing your visual voice and discovering how to express it through your art. Whether the results are good or bad, something positive can come of every artistic experience: learning, growing and taking another step toward becoming the artist you were meant to be.

CONTRIBUTING ARTISTS

Cristina Acosta
Cristina@cristinaacosta.com
www.cristinaacosta.com
Bark in the Park, 127; *Breakfast Bouquet*, 18; *Dos Rosas (Two Roses)*, 93; *Eagle No. 4*, 82; *Puma*, 100 © Cristina Acosta

Jen Bradley
jenifwa@hotmail.com
www.theschoolhousegalleries.com
www.bennettstgallery.com
Brown Pear, 104; *Pink Bowl*, 143; *Plums*, 134 © Jen Bradley

Cynthia Britain
plenairart@verizon.net
www.cynthiabritain.com
Daydream, 30; *Exotic Beauty*, 156; *Mary of Magdala*, 107; *Mata Hari*, 61; *Queen of Sheba*, 88; *Saturday Night*, 87; *Sweet Sixteen*, 127 © Cynthia Britain

Robert Burridge
rburridge@robertburridge.com
www.robertburridge.com
Adventures in Bobland, 36; *Bistro on the Balcony*, 114; *By the Beautiful Sea*, 34; *Café Beaujolais*, 40; *Café Bouquet*, 15; *Cantina Cantata*, 27; *Docking*, 57; *Fiesta Del Sol*, 72; *Magician's Chair*, 61; *Market Day*, 100; *Maui Martini*, 67; *Primavera*, 133; *Pushing Up the Sky*, 53; *Red Chair*, 157; *Solarium*, 37 © Robert Burridge

Bonnie Casey
geocasey@northlink.com
www.bonniecasey.com
Chicago, 82; *Color of the Desert*, 119; *Desert Sunset*, 132; *Feed Bag*, 51; *Glory*, 73; *Grand View*, 41; *Music in Red*, 26 © Bonnie Casey

Cheri Christensen
cheri@cherichristensen.com
www.cherichristensen.com
Can't Go Under It, 66; *The Green Gate*, 110; *The Journey Home*, 151; *The Lesson*, 93; *Oh...Pear*, 142 and cover; *Salflay*, 162; *Sunday's Pig*, 108; *The Three Fates II*, 127; *Tink on the Edge*, 88 © Cheri Christensen

Connie Connally
connie@connieconnally.com
www.connieconnally.com
Falling Away From Pink, 27; *Friends and Yellow Ball*, 115; *Hanna*, 52; *Patti Pyle and Chloe*, 141; *Princess*, 105; *Thistles and Fire*, 21 © Connie Connally

Brian Davis
www.briandavisart.com
www.collectorseditions.com
Dahlia Duet, 137; *Enlightenment*, 34 and cover; *Heather Blush Irises*, 130; *Pink and White Cactus Orchid*, 136; *Sunlight Dance*, 12; *Three Pink Dahlias*, 138; *Twin Beauties*, 82 © Brian Davis

Rhonda Egan
rhondae@surewest.net
home.surewest.net/rhondae/
www.thechromagallery.com
Boating on the River, 52; *Over the River and Through the Woods*, 163; *Taste of the Sea*, 93 © Rhonda Egan

Anne Embree
anneembree@earthlink.net
www.anneembree.com
Fusion of Deer, 102; *Must We Kill the Mouse?*, 91; *Observation*, 163; *On the Outside Looking In*, 90; *Silence of the Night*, 60; *Tried & True*, 93; *Untitled*, 26; *Watering Hole*, 115; *The Zebra*, 102 © Anne Embree

Nicora Gangi
nmanwari@twcny.rr.com
www.machairastudio.com
Beginnings Call, 127; *From the Very First*, 163; *Letter to Pergamum*, 92; *Lily and the Lamb*, 80; *One Reflects the Other*, 144; *That Which Is Revealed*, 27 © Nicora Gangi

Vince Gasparich
vince@gasparichart.com
www.gasparichart.com
Afternoon Picnic, 49; *Corrales Harvest*, 75; *Fall Orchard*, 71; *First Snow*, 139; *Mesilla Valley*, 74; *Moonrise*, 155; *Spring*, 68; *Taos Valley*, 145; *Welcome Home*, 20 © Vince Gasparich

Lawrence Goldsmith
www.lawrencecgoldsmith.com
Alternatives, 105; *Blue Sea*, 173; *Burning Off*, 24; *Choppy Waters*, 43; *Deer Pond*, 135; *Definition: Coast*, 145 © Lynda Goldsmith

Jean Grastorf
cwgfl@aol.com
www.hometown.aol.com/cwgfl/jean_grastorf.html
Canna, 10; *Plaka*, 70; *Southern Breeze*, 163; *Squares*, 57; *Window Shopping*, 32 © Jean H. Grastorf

Carole Katchen
www.carolekatchen.com
Big Is Beautiful, 120; *Tell It Like It Is*, 104; *The White Wine Drinkers*, 21 © Carole Katchen

Linda Kemp
studio@lindakemp.com
www.lindakemp.com
Cool Light, 99; *In a Tangle*, 61; *Landscape Mirage No. 4*, 122; *Red Sky*, 27; *Spring Violets*, 93; *Summer Light*, 163 © Linda Kemp

Liz Kenyon
liztration@cox.net
www.lizkenyon.com
Donut Break, 143; *Morning With Oaks*, 158; *Peachy Keen*, 126; *Pears*, 92; *Savannah Wine Barrels*, 115; *Social Hour*, 140; *Turnips*, 159 © Liz Kenyon

Madeleine Lemire
info@madeleinelemire.com
www.madeleinelemire.com
A l'Ombre du Grand Pin (In the Shadow of the Big Pine Tree), 109; *Blé Mistral (Wind on Wheat)*, 125; *Coquelicots (Poppies)*, 124; *Dans la Lumière du Matin (In the Morning Light)*, 60; *Helléniques (Inspiration from Greece)*, 106; *Le Cyprès (The Cypress)*, 141; *Les Amandiers (The Almond Trees)*, 68; *Les Arches (The Arches)*, 10; *Les Éphémères (The Ephemeral)*, 121; *Les Restanques (The Slopes)*, 42; *Les Ruines (The Ruins)*, 25; *Octobre Jaune (Yellow October)*, 123 © Madeleine Lemire

Carolyn Lord
www.lordanglin.com
www.nancydoddsgallery.com
www.binggallery.com
Almond Petal Flurries, 44; *August Afternoon*, 121; *Dixon's Ditch*, 61; *Fountainside*, 110; *Leeward Garden*, 13; *Livermore Road Ranch House*, 69; *Mint Chip Rock Pit*, 45; *Nor'Wester at Hawk's Point*, 27; *Sidewalk Divas*, 163; *Spring Dreamer: Merav*, 53; *Stepped Falls*, 145; *Tin Roof Vista*, 70 © Carolyn Lord

Peggy McGivern
peggymcgivern@aol.com
www.peggymcgivern.com
Fledglings Released, 71; *Flowered Apron*, 122 and cover; *Gardening Day*, 113; *Irish Rowhouses, Northern Ireland*, 60; *Morning Coffee*, 22; *Roller Coaster*, 97; *Whirlybird*, 19; *Who Let the Cows Out?*, 23 © Peggy McGivern

Joan McKasson
joanmckasson@cox.net
www.joanmckasson.com
By the Light of the Silvery Moon, 81; *Cool Garden Matilijas*, 105; *Garden Color*, 73; *Late Afternoon Shadows*, 31; *Poppies in My Garden*, 156; *Sunflowers, Daisies and Poppies*, 162; *Sunlit Sunflowers*, 35 and cover; *Thistles Growing Wild*, 126; *Waiting for Ryan*, 35; *Winter Light*, 109 © Joan McKasson

Helaine McLain
Helaine16@msn.com
Kemet/Deshret No. 1, 101; *Kemet/Deshret No. 2*, 61; *Kemet/Deshret No. 5*, 101; *Kemet/Deshret No. 6*, 89; *Kemet/Deshret, No. 9*, 127 © Helaine McLain

Carla O'Connor
art@carlaoconnor.com
www.carlaoconnor.com
Black Gown, 89; *Dancer*, 54; *Favorite Model*, 162; *Fern*, 55; *Gallery Walk*, 27; *The Quilt*, 15; *Untitled*, 93; *Untitled*, 131 © Carla O'Connor

Camille Przewodek
fineart@sonic.net
www.przewodek.com
End of the Day, 130; *Mongolian Memories*, 50; *Shark Harbor Surf*, 157; *Sonoma Square*, 120; *Street Scene*, 126; *The Yellow Truck*, 104 © Camille Przewodek

Barbara Rainforth
rainforthb@earthlink.net
www.home.earthlink.net/~rainforthb/
Autumn Horizon, 10; *Beach Horizon* 11, 140; *Blue Wood*, 106; *Forest Light*, 43; *Greenwood*, 127; *Saturation*, 92; *Spring Hills*, 83; *Wild Rose Trail*, 134 © Barbara Rainforth

Susan Sarback
sarback@lightandcolor.com
www.lightandcolor.com
American River Morning, 79; *Autumn Pond*, 14 and cover; *Burney Falls, Late Day*, 98; *Chabot Vineyard, Napa*, 108; *Eucalyptus Garden*, 142; *Falling Free*, 98; *Morning Pond*, 14; *Reaching Beyond*, 16; *Tulips on Glass*, 17 © Susan Sarback

Marilyn Simandle
www.marilynsimandle.com
Alaska, 42; *Grand Canal*, 96 and cover; *Network*, 69; *The Seine*, 30 © Marilyn Simandle

Shawn Snow
www.shawnsnow.com
Erosion of Architecture, 56 and cover; *Red Lake*, 61; *Seams*, 58; *Warlord*, 59 © Shawn Snow

Leslie Toms
www.leslietoms.com
Hill Town—Tuscany, 139; *The Red Barn—Rutherford*, 33; *Tanks*, 110; *Village at Sunset—Locke*, 72; *Wine Country Morning–Sonoma*, 96 © Leslie Toms

Lian Zhen
lianzhen@yahoo.com
www.lianspainting.com
Church, 147; *Ritual*, 103; *Rooster*, 154; *Rooster & Chicks*, 66; *17-Mile Drive*, 26; *Tiger*, 146 © Lian Zhen

About the Art

Art on pages 10-11, counter-clockwise from upper left: *Canna*, Jean Grastorf, watercolor, 20" × 26" (51cm × 66cm); *Les Arches (The Arches)*, Madeleine Lemire, oil, 40" × 30" (102cm × 76cm); *Autumn Horizon*, Barbara Rainforth, oil, 71" × 47" (180cm × 119cm); *Reaching Beyond*, Susan Sarback, oil, 20" × 30" (51cm × 67cm); *Sunlight Dances*, Brian Davis, oil, 30" × 24" (76cm × 61cm); *Café Bouquet*, Robert Burridge, acrylic, 48" × 36" (122cm × 91cm).

Art on pages 30-31, counter-clockwise from upper left: *Daydream*, Cynthia Britain, oil, 11" × 14" (28cm × 36cm); *The Seine*, Marilyn Simandle, watercolor, 22" × 30" (56cm × 76cm); *Late Afternoon Shadows*, Joan McKasson, watermedia collage, 26" × 20" (66cm × 51cm); *Grand View*, Bonnie Casey, oil, 30" × 40" (76cm × 102cm); *The Red Barn—Rutherford*, Leslie Toms, oil, 12" × 12" (30cm × 30cm); *Café Beaujolais*, Robert Burridge, oil, 30" × 24" (76cm × 61cm).

Art on pages 66-67, counter-clockwise from upper left: *Can't Go Under It*, Cheri Christensen, oil, 6" × 6" (15cm × 15cm); *Rooster & Chicks*, Lian Zhen, ink and Chinese paints, 16" × 20" (41cm × 51cm); *Maui Martini*, Robert Burridge, acrylic, 40" × 30" (102cm × 76cm); *Tried & True*, Anne Embree, oil, 36" × 48" (91cm × 122cm); *Village at Sunset—Locke*, Leslie Toms, oil, 12" × 12" (30cm × 30 cm); *Lily and the Lamb*, Nicora Gangi, pastel, 19" × 14" (48 cm × 36 cm).

Art on pages 96-97, counter-clockwise from upper left: *Grand Canal*, Marilyn Simandle, oil, 30" × 40" (76cm × 102cm); *Wine Country Morning–Sonoma*, Leslie Toms, oil, 30" × 40" (76cm × 102cm); *Roller Coaster*, Peggy McGivern, oil, 24" × 18" (61cm × 46cm); *Color of the Desert*, Bonnie Casey, oil, 22" × 28" (56cm × 71cm); *Market Day*, Robert Burridge, acrylic, 22" × 15" (56cm × 38cm); *Gardening Day*, Peggy McGivern, oil, 24" × 18" (61cm × 46cm).

Art on pages 130-131, counter-clockwise from upper left: *End of the Day*, Camille Przewodek, oil, 20" × 16" (51cm × 41cm); *Heather Blush Irises*, Brian Davis, oil, 22" × 44" (56cm × 112cm); *Untitled*, Carla O'Connor, watercolor and gouache, 30" × 22" (76cm × 56cm); *Moonrise*, Vince Gasparich, oil pastel, 14" × 20" (36cm × 51cm); *Social Hour*, Liz Kenyon, pastel, 25" × 30" (64cm × 76cm); *Exotic Beauty*, Cynthia Britain, oil, 16" × 11" (41cm × 28cm).

Lawrence Goldsmith, 1916-2004

Lawrence Goldsmith, whose exquisite watercolors appear in this book, passed away in 2004 at age 87, after a lifetime of painting. When I asked Lynda, his widow, what advice Lawrence might have shared with my readers, she spoke with some of his students and responded with the following insights.

Larry's advice could range from "stop painting" to "keep painting." "Stop painting" refers to not overworking your painting, particularly if it is a watercolor. For Larry, producing a watercolor in the wet-in-wet technique was a very involved process, almost a dance between the painter and the flowing paint. He advised his students to take risks, to let go and to give themselves over to the process. So much better to gamble and produce the occasional painting in which everything comes together, delighting the senses and engaging the emotions, than to turn out one safe, predictable work after another. Let go of control just a bit—or a lot—and then work with what happens. Larry thought it necessary to walk the tightrope, teetering a bit but regaining balance, in order to get the exciting results that could never come from walking along a line on solid earth. Of course it takes experience to master this dance, and that is why it is important to "keep painting," no matter what.

When he was painting outdoors on a daily basis every summer, Larry was asked what to do if one wakes up with no idea for a painting and no energy to paint. He said, "Go out and paint anyway." When he developed macular degeneration and was confined to working indoors, being too unsteady on the trails and rocky headlands he had formerly called his outdoor studio, he still painted every day. And he still had those phenomenal bursts of creation so that breathtakingly beautiful paintings came along with the failures. When a younger painter who had just been diagnosed with macular degeneration came to him in despair, Larry pointed out that he still had his good days and told him, "You must keep painting, you know."

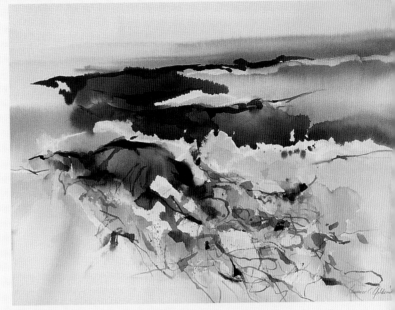

Capturing the Essence of the Sea

Goldsmith loved the sea and spent thirty-seven summers painting on Monhegan Island off the coast of Maine. Here he paints a pure, intense blue with strong contrast to reflect a bright, crisp day on a running sea. Inspired by the spiritual and emotional essence of the island scenes, he collected impressions to paint in his Vermont studio during the winter. English artist-writer Ron Ranson says in his book *Distilling the Scene* that Goldsmith didn't paint how a location looked; he painted how it felt. Perhaps this is why the artist has been called the "Zen Master of watercolor."

BLUE SEA | Lawrence Goldsmith | Watercolor
18" × 24" (46cm × 61cm)

INDEX

Metric Conversion Chart

To convert	to	multiply by
Inches	Centimeters	2.54
Centimeters	Inches	0.4
Feet	Centimeters	30.5
Centimeters	Feet	0.03

LOOK FOR THESE OTHER FINE NORTH LIGHT BOOKS!

These books and other fine North Light titles are available at your local fine art retailer or bookstore or from online suppliers.

Donald Voorhees

Donald Voorhees has been painting and teaching in watercolors for most of his life. *Lessons from a Lifetime of Watercolor Painting* is packed with more than 25 demos that make it easy for beginning artists to visualize and practice different techniques. Anecdotes, insights, tips and tricks are scattered throughout the book, all designed to help you get an artist's sense of watercolor painting. Easy to use, the book utilizes tabs for quick access to specific techniques and subjects. Whether you're a beginner or advanced artist, you will find inspiration and guidance within these pages.

ISBN-13: 978-1-58180-775-2 | ISBN-10: 1-58180-775-9 | HARDCOVER WITH SPIRAL BINDING, 144 PAGES, #33446

Struggling with creative block? Looking for new and exciting ways to grow your work? If so, *The Artist's Muse* is just for you! This unique book and card game kit is packed with creative prompts and idea sparkers. By mixing and matching cards, and following the book's visual examples, you will discover a world of creative possibilities that leads you to a more personal and confident artistic style.

ISBN-13: 978-1-58180-875-9 | ISBN-10: 1-58180-875-5 | KIT, 96 PAGES, #Z0345

The overwhelming beauty of the outdoors is one of the most inspiring—and elusive—subjects for painters. With *Landscape Painting Inside & Out*, Kevin D. Macpherson shows you how to see like an artist and how to re-create your vision into stunning outdoor scenes. Take your art to the next level with Macpherson's insightful process and inspiring commentary about the painting life.

ISBN-13: 978-1-58180-755-4 | ISBN-10: 1-58180-755-4 | HARDCOVER, 144 PAGES, #33422